C0-AOF-825

MAINE,
A PEOPLED LANDSCAPE

A Production of the Salt Center for

Documentary Field Studies

MAINE, A PEOPLED LANDSCAPE

Salt Documentary Photography,
1978 to 1995

Edited and with an introduction by
Hugh T. French

Essays by
C. Stewart Doty, James C. Curtis,
and R. Todd Hoffman

WITHDRAWN

UNIVERSITY PRESS OF NEW ENGLAND / Hanover and London

SCCCC - LIBRARY
4601 Mid Rivers Mall Drive
St. Peters, MO 63376

University Press of New England, Hanover, NH 03755

© 1995 by Salt, Inc.

All rights reserved

Printed in the United States of America 5 4 3 2 1

CIP data appear at the end of the book

CONTENTS

FOREWORD

Robert Coles

WHAT FOLLOWS is a treasure of sorts—the documentary tradition of interviews and of photography as it has been connected to a particular locale, that of Maine, and to a particular time, that of the late twentieth century. As I looked at these pictures, read the statements of ordinary people (and those who went to watch them, to make a record of an aspect of their lives), I kept remembering remarks made by William Carlos Williams as he went about his medical life in northern New Jersey—home visits to humble folks, whom he not only treated but watched very closely and, later, tried to present to others in the mix of their language and his that gave his poetry its singular power and authority. He knew what he had witnessed, but he also worried about what may have gone unnoticed by him or, of course, been kept from him. He also knew that the way he portrayed the world he had come to know was only one of several (even many) evocations possible—all depending on the person doing the writing or the photography, the telling or representing of various scenes.

Once, frustrated, perplexed, not a little irritated, he dwelled at some length on the difficulties he was having as he tried to do justice to "life along the Passaic river," the title he gave to a collection of his stories, but also a phrase I heard him use often as he tried to summarize a world he'd spent almost a half century getting to know as a doctor, as a writer with a keen interest not only in his own sub-

jectivity, but that objectivity of streets and homes and factories and schools and stores and the beings who occupy them, spend time in them, frequent them. He had urged us all (urged himself) this way, in his great lyrical poem *Paterson:* "outside/outside myself/there is a world," a world he knew worthy of thorough exploration—yet, he had his worries as to how he ought to do so, and whether, having done so, he had been more or less accurate, or had stumbled badly. "Damn if I know how to take in this world and then give back what I've learned," he said—an absurd statement, I thought at the time, one that merely expressed the inevitable exasperation of a conscientious writer, humble enough not to be all too sure of himself, all too smitten with his own efforts. Now, many years later, I think I know the frustration he felt, the alarm that bespeaks a gnawing sense that for all that has been recorded and rendered, Lord, there is more to be seen and heard.

So it went for one of our most gifted poets and essayists, and so I suspect it goes for all of us who choose to look carefully at a patch of land, and the people who live on it, then convey to others what we have heard, seen. Such an effort, always, is a shared one—we are not only observing, documenting, but we are saying something, presenting something of ourselves. Every scene, after all, lends itself to the one who views it, tries to chronicle its events, and that person brings to the work being done his or her life, its assumptions and

interests, its experiences and achievements and disappointments and grudges, its blind spots and its times of impaired or distorted hearing. So often we find what we seek—and offer it as "reality." Not that there aren't, naturally, many realities—but it is best to acknowledge, right off, that documentary work is a wonderful mix of the *here* of the writer, the photographer, yes, even the oral historian (who, after all asks *this*, pays heed to *that*, and edits all that has been spoken) and the *there* of the neighborhood, the region whose life (in part, always) is being set down for the perusal, the edification, the enjoyment of others.

This book is an important addition, indeed, to that documentary tradition—its direct observation of Maine is done with great dignity and subtlety, and makes for a compelling and instructive experience on the part of the reader and viewer. There is, too, some very important and instructive social and intellectual history in these pages—a valuable discussion of earlier documentary research done in Maine, and a first-rate analysis of the limits of and possibilities in such work. The Salt Center for Documentary Field Studies is at once a localist treasure and a national one: Its work is intimately tied to a given world, but its work connects, needless to say, with other worlds, tells us all, yet again, what it means to live, to hope, to struggle, to win and to lose, to be a certain kind of American at a certain moment in a nation's history. Those of us fortunate enough to come upon this book, and ready to accept it, as a teacher, will (through our various responses) also learn about our own lives, learn by the comparisons we make, learn by what strikes us as significant, by what excites us or worries us or dismays us—no small offering for a book to make.

MAINE,
A PEOPLED LANDSCAPE

SALT AND MAINE'S CHANGING FACE

Hugh T. French

A 410 FOOT cargo vessel of English registry, the *Ravenswood,* pulled away from the breakwater of the tiny coastal border city of Eastport, Maine, in May of 1981. For a week its towering hulk had dwarfed the streets and buildings of the community as longshoremen loaded it with wood pulp headed for Europe. Now the community had come to celebrate the ship's departure. Cars crowded the small parking lot in the middle of Water Street fronting the breakwater. People stood on the edge of the shore and waved. Drivers honked their horns. The ship's horn responded in kind.

There was a sense that this scene wasn't really happening at all. It wasn't supposed to happen. Not in Eastport. A place that had lost nearly two-thirds of its population since the turn of the century, along with most of its industry. People stood on the shore and sat in their cars in the lot and watched the ship pull out into Friar Roads—the same deep waters where the last Boston to Eastport steamer pulled out fifty years earlier in 1931. People appeared transfixed, frozen, all heads and eyes directed toward the ship as it slowly made its way out of Head Harbour Passage in the neighboring Province of New Brunswick and disappeared between Deer and Campobello Islands. Then it would move out into the Bay of Fundy and onward to the North Atlantic. There was a sense, without knowing entirely why, that something fundamentally was changing. That somehow this was an important day.

It *was* an important day, for fourteen years later, cargo ships continue to load in Eastport. It was one of many important days, some good, some bad, that Maine would experience during the 1970s and 1980s. For Maine was indeed experiencing fundamental change, a change that would force Mainers to look hard at themselves and their place, to make decisions about the changes affecting their place. It is this dealing with change that was to be Salt's focus during the seventeen-year period this book covers.

For four years, Salt worked to document that change in Eastport. A scene that was repeated—sometimes differently, sometimes on a far vaster scale—across the state. The return of shipping to Eastport was just one part of a widely and wildly played out drama that saw the birth of new industries, the death of old, the defeat of some that were proposed, the influx of new and different sorts of residents, the continued out-migration of natives. Scores of interviews were conducted by Salt during this time. Thousands of frames of film were shot. Of sardine factory workers. Politicians. Storytellers. Newcomers. Oldtimers. Entrepreneurs. Enough for Salt to publish an entire book about Eastport.[1]

For twenty-two years, Salt has worked to document change and continuity in Maine. A place that has at times resisted change better than other parts of the country, sometimes in spite of itself, sometimes because of itself. A place that during the last quarter of a century

has became increasingly particular about what change it would allow. To document what was happening, Salt has gone to Madawaska, to Lubec, to Rangeley, to Indian Island, to Kennebunkport, to Portland. It has snow-shoed seven miles in March to Lake Mattagamon to talk to a dean of Maine guides. It has dived underwater to photograph sea urchin divers in Casco Bay. It has traveled more than 10,000 miles in ten weeks to document the only passenger rail service in Maine criss-crossing the state from east to west.

At times, Salt's work has been hampered by insufficient money. At other times, by time itself. Water pipes have frozen up and burst in our photographic darkrooms. The humidity of August has turned our labs into swimming pools. Roofs have leaked. Furnaces have faltered. But the work has continued. Over the past seventeen years, the bulk of Salt's 250,000 photographs have been taken.

The work first began as part of an educational program at the high school level in 1973, and then made the transition to the undergraduate college level in 1981. Today half of the students are advanced undergraduates, the other half postbaccalaurates, many of whom are in the process of earning advanced degrees. Students come to study for a semester at the Salt Center for Documentary Field Studies in Portland from as nearby as Portland and from as far away as Australia. They are taught to document a place (Maine) by an interdisciplinary faculty of people who have done documentary fieldwork themselves: photographers, editors, historians, and anthropologists. Documentary content drives the work. Acquiring the professional skills to do good documentary work is an enabling consequence.

As the Salt Center evolved into an advanced level educational institution, so too has its photography evolved. Salt broadened and deepened its choice of subject matter over the years. In the first five years of its life Salt focused on collecting life stories and documenting traditional crafts and work of single individuals. During this next stage Salt tackled broad new subjects in a more complex and complete way.

Seventeen years later, a critical mass of this "new" Salt documentary photography has been reached—in both the magnitude of work and the breadth and depth of subject matter. It makes sense now to take a retrospective look at that photography and see what it tells about photography at Salt and what it tells about Maine.

Almost all of the Salt photography contained in this book first appeared in the periodical, Salt, that is published by the Salt Center. The negatives had been deposited in the Salt Documentary Archive for preservation. The Salt Archive contains over 250,000 photographic negatives and about 3,000 prints. There is a complementary tape-recorded interview collection of roughly 2,500 hours, most with accompanying transcripts. In many ways the archive serves as a time capsule for contemporary Maine.

The Salt photographs found within this book reflect a still largely rural, sparsely populated place. A place of small towns and small cities. A place that has become more diverse in its peoples and in its workplaces. More inclusive of its residents, as its women and its ethnic populations and its marginalized people gain new ground.

The Salt photographs are organized into four categories for this book: the coast, inland, work, and community. Many fit easily into more than one category, but these categories are meant to be suggestive. Suggestive of Salt's approach to photographing people and their place and of what has been happening in Maine during the past seventeen years. Wherever possible, two photographs have been chosen and displayed together from a photographic essay of a single photographer to suggest some of the depth and breadth of that work. More have not been shown, so that single images could represent a wider range of Salt's work over the past seventeen years. In total, the Salt photographs here represent the work of thirty-nine students, three of their teachers, two instructors, and two photographic fellows.

Salt spent four years undertaking documentary work in Eastport because in many ways Eastport was a window onto some of the changes happening in Maine. Among them was a population shift. In 1980, for the first time in eighty years, Eastport did not lose population. It didn't gain population either, but on the surface things appeared to have stabilized.

Beneath that exterior of stability, large changes were happening. Long-time natives shook their heads in disbelief as people "from away" paid good money for old houses. What are they going to do for work, Eastporters asked. Why would they move to the end of the earth?

These new arrivals were part of an accelerated shift in Maine's population patterns. Historically Maine has grown very slowly. The state's population grew by about the same number, roughly half a million, in a ninety-year period between 1810 (a decade before it became a state) and 1900, as it did in a second ninety year period, between 1900 and 1990.

What was happening between 1970 and 1990 was a surge in population growth of nearly a quarter of a million people—almost half of the growth for the entire second ninety-year period. This represented the biggest surge in Maine's population since the period after the American Revolution between 1810 and 1830 and again between 1830 and 1850, when Maine's population also grew by nearly 200,000 in each twenty-year period.

This growth was not at all even throughout the state. Aroostook County in the north continued to lose population and was predicted to continue to do so through at least the turn of the century. The closing of the Loring Air Force Base at the end of 1994 was but another reinforcement to this trend. Washington County in the east grew by about one percent. In 1990, Washington County had about the same population it had a century earlier.

Nearly half of the 230,000 increase between 1970 and 1990 was concentrated in Maine's two southernmost counties—York and Cumberland. Here could be seen any number of towns doubling, even tripling in size in twenty years. The town of Lyman in York County saw its population grow from 864 in 1970 to 3,390 in 1990. Shapleigh grew from 559 to 1,911. Waterboro from 1,208 to 4,510.[2]

People were moving to Maine, and they were moving for strong personal reasons—for a quality of life not found elsewhere, for a place less urban, less developed, less hectic, and with extraordinary natural beauty. They were moving to Maine's small towns, not its cities. This was in direct contrast to the immigrants, principally from Quebec, who came in search of

work in Maine's industrial cities in the period from 1850 to 1900. On average, these new migrants of the 1970s and 1980s were younger than Maine's existing population with significantly more years of formal higher education. They had strong interests in protecting the environment. They were teachers, professionals, technicians, back-to-landers, craftspeople. They have had and will continue to have an enormous impact on the state.[3]

The growth in population had side effects beyond a sheer increase in numbers of people. Property values escalated dramatically in southern Maine and the choicest places elsewhere, placing severe financial pressures on fixed and lower income property owners to pay escalating property taxes. One study Salt did at the end of the 1980s involved the Tyng and Tate Streets neighborhood in Portland. Between 1980 and 1989, over seventy percent of the property of this tiny two-block-square neighborhood had changed hands. One property sold in 1982 for $20,000. By 1988, the same property had changed hands three times, been converted into four condominiums, and sold for $200,000.[4]

In the coastal town of Castine, as elsewhere along the coast, there were fears that "natives" could no longer afford to live in the towns they had grown up in. These fears are reflected in *Salt*'s article, "Pristine Castine." The state enacted a circuit breaker bill to help alleviate the situation by providing funds to offset these higher taxes based on one's ability to pay.[5]

Other responses to growth included the proposed expansion of the Maine Turnpike from two to four lanes in each direction along a thirty-mile stretch from York to Scarborough. In a hard-fought, bitter referendum campaign, voters in all of Maine's sixteen counties defeated the referendum. There was a sense that the pace of change was going too fast. That a wider road would bring still more people into Maine. That Maine could not follow the lead of California or New Jersey in accommodating growth. In 1987, in Portland, voters of the city enacted a five-year waterfront moratorium to halt continued conversion of the "working" waterfront to nonmarine uses. The waterfront battle was sparked by the conversion of two wharves to plush condominium complexes.

Here, again, there was a sense that things were changing too fast. Without some sort of working waterfront, would Portland still be Portland? Growth also threatened to change the use of Maine's 18 million acres of woodlands as well as open spaces. There were fears that the large timberland owners would sell chunks of land for residential and second-home developments. In response a $35 million state bond issue was passed by voters to purchase the best of Maine's land threatened by development. Local land trusts grew dramatically.[6] The state enacted a mandated comprehensive planning bill that sought to achieve greater planned growth within Maine's communities. State funding for the program was gutted when the state experienced a recession in the late 1980s.

Alongside with accelerated development came clear signals that a shakedown in traditional areas of economic activity was taking place. They were being defeated, maxed out, or obliterated. In the case of Eastport, the city had just endured a fifteen-year bruising battle over the siting of a billion-dollar oil refinery on its land. This was one of the last of a series of attempts to site heavy industry on the coast of Maine during the 1960s through 1970s. The proposal lost in 1983. By that time, the last remaining sardine factory in Eastport had closed its doors. This in the city where the industry first began in 1875 and where more than twenty factories once jostled along the waterfront, working day and night—employing over two thousand workers. In 1993, only six sardine factories were working along the entire coast of Maine where seventy-five had once been.[7]

Then, in phoenix-like fashion, the salmon aquaculture industry rose from almost out of nowhere to take the sardine industry's place. In the next few short years, this industry grew phenomenally fast, much like the sardine industry had grown a century before. The parallels are eerie.

This new industry, too, like cargo shipping, seemed strangely different—because it was—from what had gone on before. Fish were raised in suspended pens on the ocean surface, not caught by nets dragged behind a fishing vessel. By the early 1990s, Eastport, which formerly described itself as the sardine capital of the world, became the center for salmon aquaculture in Maine.

The entire fisheries of the state, with the lobster fishery perhaps least affected, went topsy-turvy. In Lubec in 1991 came the closing of the last American smoked herring factory—an industry employing much the same technology and work patterns as found in France in the 1600s. Salt was there in 1984 and 1985 to record this "old world" enterprise. Catch of groundfish plummeted. The Northeast's cod landings in 1980 added up to 53,500 metric tons; in 1990 they were 43,600 tons. The groundfish catch of haddock almost completely disappeared: 27,600 tons in 1980, 2,500 tons a decade later. The legal resolution of the Canadian-American 200-mile offshore fishing limit on Georges Banks further constricted the fishing areas for Maine. Stricter regulations were put in place to allow the fish stocks to rebuild. Many young Maine fishermen headed west to Alaska for months at a time where fishing was better.

New efforts began to offset these declines. In 1985, the city of Portland launched a nonprofit fish exchange on the city's fish pier—the first open display fish auction in the eastern United States—as a way to gain a better quality of fish and a better price for fish for Maine fishermen. In 1994, Portland became the biggest port of landed fish in New England. Aquaculture and the harvesting of ignored species came to the fore. In 1993, farm-raised salmon was the second most valuable fishery in Maine, second only to lobster. In addition farm-raised mussels became a valuable fishery. Sea urchins—long considered a nuisance—became much sought after in the later 1980s for the Japanese market. By 1993, sea urchins represented the third most valuable fishery in the state, worth 27 million dollars.[8]

Much the same story was found with agriculture. The number of dairy farmers dropped continuously. In a span of fourteen years, from 1978 to 1992, the number of commercial dairy farms in Maine dropped by over half—from 1,837 in 1978 to 832 in 1992. The number of potato farmers dropped from 1,287 in 1978 to 770 in 1992. Potato farm acreage dropped from 114,904 acres to 87,650. The poultry industry went belly up.

But the sharp decline witnessed after 1940 in the amount of farmland and number of farms came to an end in the late 1960s. While the total number of farms in Maine had dropped from 39,000 in 1940 to fewer than 7,000 in 1969 and the number of acres of farmland dropped from 4.2 million acres to 1.5 million acres, the number of farms actually grew slightly in the 1970s. By 1992, there were 5,776 farms in Maine. This was partly a result of inmigration, with large numbers of new arrivals undertaking small-scale farming. Community-supported agriculture farming began to arrive on the scene. And here too, as with the fisheries, the unimaginable was happening as well. Broccoli began to be grown in Aroostook County in the early 1980s, and by 1993 over 3,000 acres were in cultivation. Salt spent weeks in the broccoli fields. Another crop found a marketing niche. The blueberry harvest grew greatly, aided by new freezing technologies, new growing techniques, and the promise of new mechanical harvesting. Salt was there for the blueberry harvest in 1985, just as change was beginning and the hand harvest was about to be challenged. We watched a hand raker race the new machine—and win. The 1992 crop was the largest in the industry's history, with 84 million pounds of blueberries harvested.[9]

In another significant indication that Maine's economy was changing, between 1982 and 1992, the number of service jobs in Maine surpassed the number of manufacturing jobs for the first time. The number of jobs in manufacturing remained fairly constant from 1950 to 1990. The number in service grew by 400 percent in the same period. Maine's economy was becoming more diversified. The number of textile knitting and weaving machine operators dropped from 3,304 in 1950 to 750 in 1990. The number of lumbermen, raftsmen, and wood choppers dropped from 8,740 in 1950 to 3,192 in 1990. In 1900, Bates textile mill in Lewiston employed 2,000 in five mills—in 1989, fewer than 150 in one mill. Permanent closure threatened this mill. Then a large upscale clothing company, Boucher Boys and the Indian, contracted with Bates to make Pueblo design blankets. Employment stabilized at 100 by 1994. Salt examined this shift from a manufacturing to a service economy in a study compar-

ing the Bates mill and the L. L. Bean telemarketing workplace.[10]

Not only were Maine's population and economy changing, but the historical relationships between parts of this population were changing as well. Maine became a more inclusive, perhaps more humane place. Perhaps the most dramatic and rapid change came with Maine's Native Americans. Long consigned to small reserves, the Passamaquoddies along with the Penobscots and Maliseets won a land settlement in 1980. The settlement was based on an unfulfilled treaty of 1793 that agreed to provide lands for Indians. Eighty million dollars was provided by the federal government to the Penobscots and Passamaquoddy tribes with the understanding that a portion of the funds would be used to purchase lands. A lesser sum was provided to the Maliseets. It would be another twelve years before a more modest settlement of $800,000 was reached between the federal government and a fourth, federally unrecognized, Indian tribe in Maine, the Micmacs.

Native Americans in Maine now were an economic force—something that was totally unimaginable before 1980 in a dominant white society. The Indians bought land to expand their reserves. The Passamaquoddies purchased Northeast Blueberry Company in Machias. They purchased the water company in Eastport. They purchased the Dragon Cement Company in Thomaston, invented a new antipollution scrubbing device, and sold the company five years later for a $100 million profit. In the late 1970s, Salt interviewed three generations of Penobscots on the eve of the land claims settlement. There was large uncertainty as to what that settlement might bring, but there were high expectations. In the early 1990s, Salt talked to a Micmac family that showed the continuing strains of living in a white society, the struggle to keep its cultural traditions. Salt also talked to young Native Americans who were attending Lee Academy, near Lincoln, but far removed from the Passamaquoddy reserves, who were taking part in a new Native American curriculum program. Again, how could they maintain traditions in a white society?[11]

No less dramatic, if perhaps more gradual, was the change with women. In 1973, there

were 19 women members of the Maine State Legislature (18 representatives and 1 senator). In 1993, there were 59 women members of the legislature (48 representatives and 11 senators) making up nearly a third of the total membership. Women were entering the workforce in far larger numbers, and in occupations in which they had had little presence before. From 1950 to 1990 the number of women lawyers and judges grew from 19 to 729. The number of physicians from 35 to 548. The number of police from 3 to 122. The number of accountants from 146 to 3,120. Women also made gains in the trades. Electricians from 9 to 297. Carpenters from 41 to 297.[12]

The popular perception of Maine is a place populated by Yankees. The U.S. Census Bureau tends to back this up, with statistics that place Maine as the second whitest state in the Union, behind Vermont. Yet this ignores Maine's Franco-Americans, representing roughly twenty-five percent of Maine's population. The Franco-American cities of Biddeford and Lewiston had long been snubbed by such Yankee cities as Portland. In 1977, Lewiston launched a Franco-American Festival. Biddeford followed suit with its own La Kermese Franco-Americaine festival in 1983. In 1990, Congress enacted the Maine Acadian Culture Preservation Act to recognize the Acadian French contributions to America and to tell that story. The Franco-American Center opened at the University of Maine in 1971. Scholarship and writings on the Franco experience in Maine mushroomed. In 1993, both houses of the Maine legislature were led by Franco-Americans. For the Franco-Americans it was a long coming of age.[13]

In 1987, Portland had its first major gay rights parade with over 200 marchers. From 1977 to 1991, the state legislature took up a gay rights bill eight times. Each time it rejected the legislation. In 1992 Portland voters approved by referendum vote a gay rights ordinance. The following year, Lewiston voters voted down such an ordinance. For the gay community, the murder of a young gay man, Charles Howard, thrown from a bridge in downtown Bangor in 1984, symbolized these tensions.

How well has Salt documented this period in Maine of change, resistance to change, and continuation of tradition? There are difficulties in assessing any photographic effort. Salt sought to overcome some of these difficulties by asking both practicing photographers and scholars of the history of photography to analyze and assess the work. The three essays that accompany the Salt photographs in this book provide differing and complementary "takes" on the Salt photography. Two are written by historian/scholars of the Farm Security Administration photographic effort of the 1930s and 1940s. C. Stewart Doty of the University of Maine and author of *Acadian Hard Times: The Farm Security Administration in Maine's St. John Valley, 1940–1943*, situates Salt's photography within a longer twentieth century tradition. James C. Curtis, director of the Winterthur Program in Early American Culture at the University of Delaware, and author of *Mind's Eye, Mind's Truth: The FSA Photography Reconsidered*, compares and contrasts Salt with the FSA. The remaining essay is written by a working documentary photographer of more than twenty years' experience. R. Todd Hoffman, director of Salt's photographic program since 1990 and former photographic editor of the *Christian Science Monitor*, examines Salt's photographic efforts from the perspective of an insider and of a practitioner.

The reader can decide how successful these efforts at assessment have been. The discussions among the three authors during meetings reviewing the essays provide a suggestion of the difficulties. In talking about the issue of "truthfulness" in documentary photography and in Salt's photography in particular, Todd Hoffman commented that he and the scholars were coming from two different cultures— he from a concern for whether the subject matter was physically rearranged either before or after a shot was taken, they from a concern for what ideological perspective the photographer was shooting from. In telling the tale of working with a University of Maine photographer to reshoot the same Acadian people and scenes that were shot 40 years earlier by the FSA, Stewart Doty related his working as a "gopher"—of driving the photographer from place to place. He said that to pass the time he would try to guess where the photographer would position himself to take his next shot. Todd

asked Stewart how often he guessed correctly. Stewart replied, "Rarely."

To continue the thread of assessing documentary photography at Salt, a major exhibit has been assembled for a statewide tour beginning with an opening at the Portland Museum of Art in June of 1995. At the same time, a one-day conference will take place at the Museum of Art involving the authors of the accompanying essays in this book as well as two additional scholars, Miles Orvell of Temple University and Wendy Kozol of Oberlin College, and two additional practitioners, Alex Harris of the Center for Documentary Studies at Duke University and Rose Marasco of the University of Southern Maine. The entire photographic project has been supported, in part, by the Maine Humanities Council through funds received from the National Endowment for the Humanities.

NOTES

1. *Eastport for Pride, Salt* (Nos. 21 and 22, December 1983).

2. U.S. Census, 1790–1990. For views on the nature of change in Maine during the last quarter of a century see, for example, *Changing Maine,* edited by Richard Barringer (Portland, Maine: University of Southern Maine, 1990), *Maine: Fifty Years of Change, 1940–1990,* edited by Allen Pease and Wilfred Richard (Orono, Maine: University of Maine Press, 1983), and Mitch Lansky, *Beyond the Beauty Strip: Saving What's Left of Our Forest* (Gardiner, Maine: Tilbury House, 1992).

3. Louis A. Ploch, *Immigration to Maine, 1975–1983,* Maine Agricultural Experiment Station, Bulletin 820 (Orono, Maine: University of Maine, 1988).

4. Amanda Holmes, "Two City Streets," *Salt* (No. 40, December 1990), pp. 26–49.

5. Beth Greenfield, "Pristine Castine," *Salt* (No. 42, September 1992), pp. 50–64. The *Portland Press Herald* reported in its November 22, 1994, edition that Freeport native Gregory Rines purchased a house in the town in 1980. His taxes were at first about $300 on property valued at about $68,000. By 1994, the value of his property had risen to nearly $200,000 and his taxes to more than $3,000. Rines moved to inland Pownal with a new home and five acres of land and half the property taxes *(Portland Press Herald,* November 22, 1994, p. 2B). The state legislature enacted a property tax relief program in 1989.

6. The turnpike widening was defeated in a referendum by Maine voters in November 1991. The language of the referendum question linked the widening defeat to the establishment of a state transportation policy. The state's comprehensive land use planning law was enacted in 1988. State-wide referendum approval of $35 million for purchase of land threatened by development occurred in 1987 at the height of the 1980s boom.

7. For an account of some of the struggles to site heavy industry along the Maine coast in the 1960s and 1970s, see Peter Amory Bradford, *Fragile Structures: A Story of Oil Refineries, National Security, and the Coast of Maine* (New York: Harper's Magazine Press, 1975). For an account of the Eastport oil refinery proposal, see *Eastport for Pride* (*Salt* No. 21 and 22, December 1983). For the situation of the sardine industry in Maine in 1993, see *Portland Press Herald,* August 16, 1993.

8. For an account of the sea urchin industry, see Joan Amory, "Urchins!," *Salt* (No. 45, September 1994), pp. 6–30. For a look at Maine fisheries today, see the six-part series of articles published in the *Portland Press Herald,* September 18 to September 23, 1994.

9. U.S. Department of Agriculture, Census, 1992. See also *The Farms of Maine,* Atlas of the Resources of Maine (Portland, Maine: Center for Research and Advanced Study, University of Southern Maine, 1986). For a look at the broccoli crop, see Kristin Atwell, "Broccoli Harvest," *Salt* (No. 46, December 1993), pp. 20–45.

10. See *The Economy of Maine,* Atlas of the Resources of Maine (Portland, Maine: Center for Research and Advanced Study, University of Southern Maine, 1985). See also *The Forests of Maine,* Atlas of the Resources of Maine (Portland, Maine: Center for Research and Advanced Study, University of Maine, 1987), and Mitch Lansky, *Beyond the Beauty Strip.* For the Salt study, see Dan Stewart, "A Tale of 2 Workplaces," *Salt* (No. 43, August 1993). pp. 42–62.

11. See for example articles by Harald Prins ("Passamaquoddy," "Penobscot," Maliseet," and "Micmac") in *Native America in the Twentieth Century: An Encyclopedia,* edited by Mary B. Davis (New York: Garland Publishing, 1994), pp. 328, 339, 435–436, 441–442. For examples of Salt's work with Maine Native Americans, see William Ibelle, "In Search of the 20th Century Penobscot," *Salt* (No. 20, January 1983), pp.30–72. See also unpublished manuscripts completed at the Salt Center by Pamela Green, "The Seventh Generation" (1993), and Jennifer Raitt, "Living Two Lives: Micmac Tradition in the Sanipass Family" (1994).

12. U.S. Census, 1950, 1970. In 1996, Salt will publish a book on its own work exploring the experience of women in Maine over the past decade.

13. On the rise of scholarship on the Franco-Americans in Maine, the author of another essay in this book, C. Stewart Doty, wrote two significant books during this period, *The First Franco-Americans: New England Life Histories from the Federal Writers' Project, 1938–1939* (Orono, Maine: University of Maine at Orono Press, 1985) and *Acadian Hard Times: The Farm Security Administration in Maine's St. John Valley, 1940–1943* (Orono, Maine: University of Maine Press, 1991). The Maine Historical Society published a series of articles on the Franco-American experience in Maine in its *Quarterly* during the 1980s. The writer, Denis Ledoux, explored his Franco-American background in a series of short stories, *What Became of Them and Other Stories from Franco America* (Lisbon Falls, Maine: Soleil Press, 1988).

THE
COAST

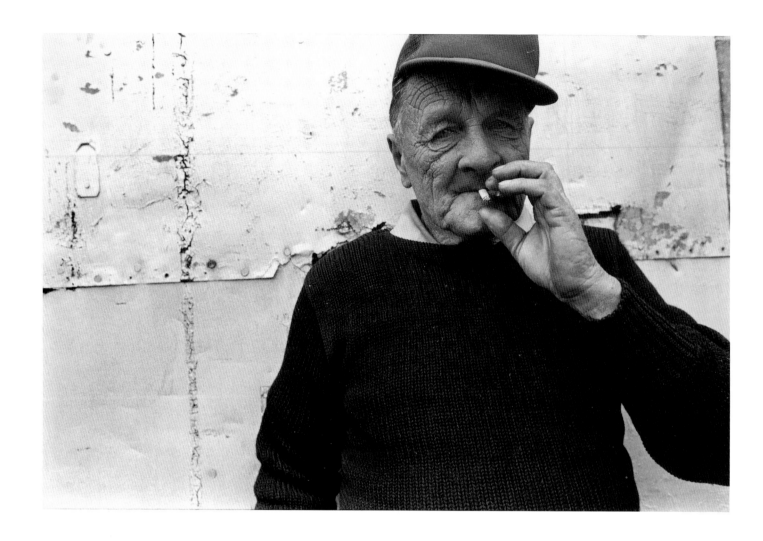

*"THE WATERFRONT should be exactly what it is for, waterfront
people. Not yuppies down on the chicken coops. Most of them figure they
would make a profit on the sale of places. They don't want to live there."
John Macgowan, Custom House Wharf owner, about waterfront condos.*

FONNIE, A RETIRED FISHERMAN. CUSTOM HOUSE WHARF, PORTLAND. 1987.
PHOTOGRAPH BY PAM BERRY.

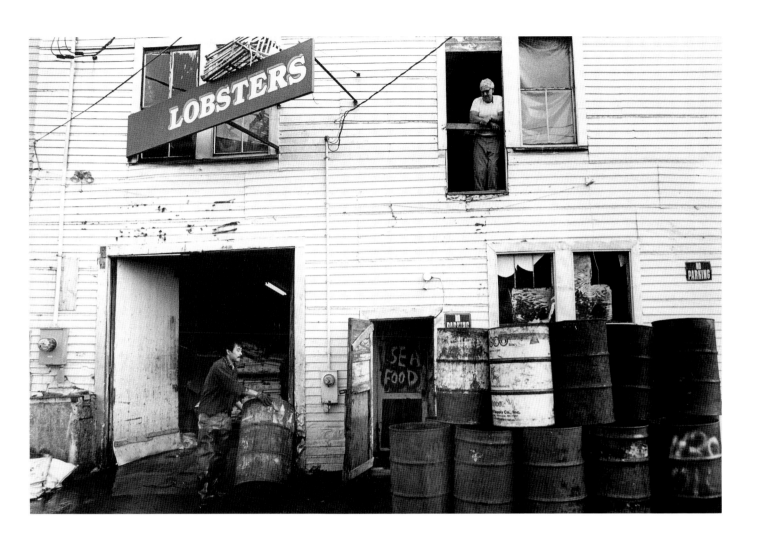

"THIS WHARF does resist change. I think because the businesses on the wharf are really well established. There really isn't any need for change. That might bother some of the people who are looking for development."

Dana Neuts, retail manager, Harbor Fish Market, Custom House Wharf.

CUSTOM HOUSE WHARF, PORTLAND, A YEAR BEFORE THE PULLOUT BY CASCO BAY LINES FERRY TERMINAL. 1987.
PHOTOGRAPH BY PAM BERRY.

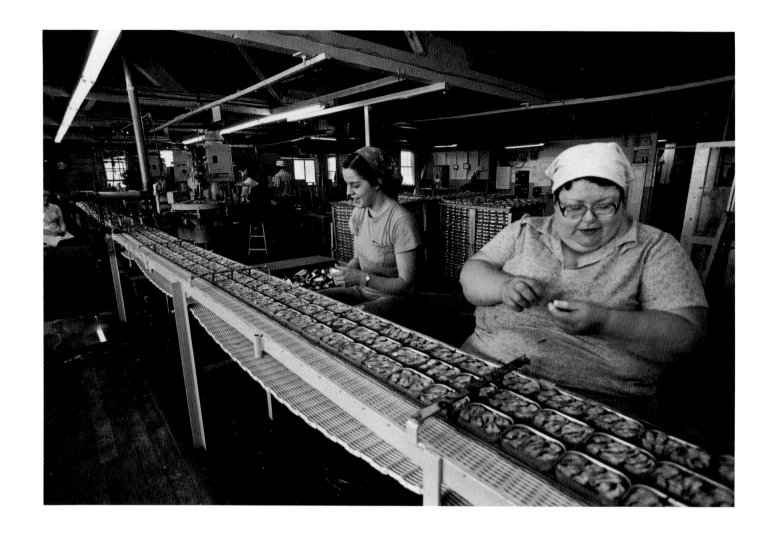

"*I WAS FOURTEEN. I left school. I thought I was gonna get rich in the factory, and I'm sorry now that I left. Still packing fish. Over fifty some odd years. . . . I've slowed up a lot 'cause I'm scared of getting cut.*"
Frances Miller, packer, Port Clyde sardine factory, Eastport.

WOMEN PACKING SARDINES. PORT CLYDE SARDINE FACTORY, EASTPORT. 1981.
PHOTOGRAPH BY LYNN KIPPAX, JR.

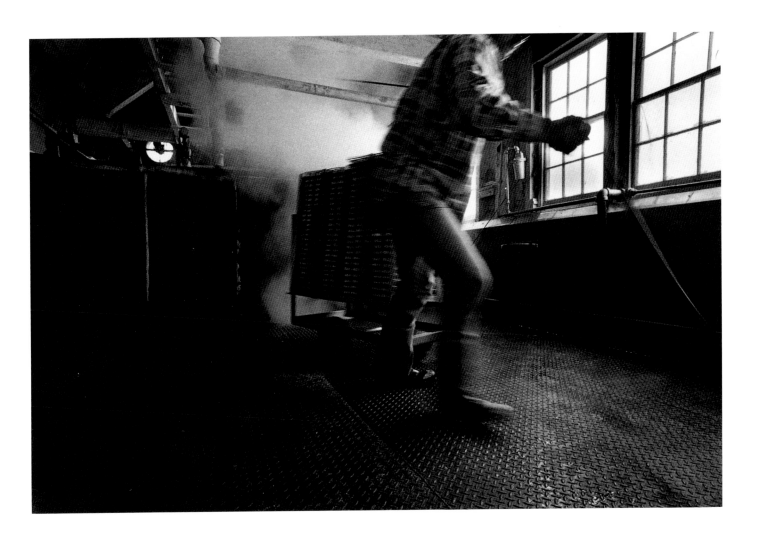

"IT WAS ALWAYS highly competitive. It was always dog eat dog." Moses Pike, who sold his sardine factory in 1979, a factory he had owned and run for 42 years. Three years later, the Port Clyde sardine factory, the last in Eastport, closed for good.

REMOVING CASES OF PACKED SARDINES FROM STEAM RETORT. PORT CLYDE SARDINE FACTORY, EASTPORT. 1981.
PHOTOGRAPH BY LYNN KIPPAX, JR.

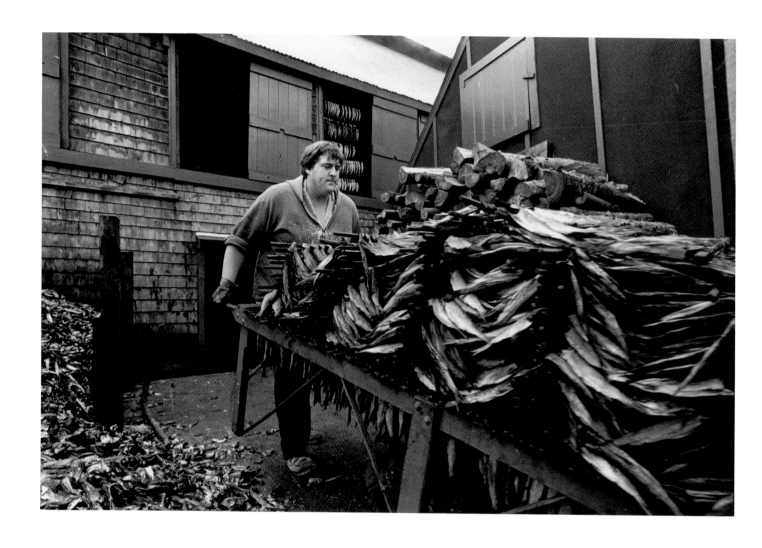

"I GOT three or four fellows worked for me for a good number a years. I've got ladies here that worked here for years. Maybe that's the only reason there's one left in the country here. Just too much handling." John P. McCurdy of his herring smokehouse that closed in 1991.

DAVE MARSTON WHEELING STRINGS OF SMOKED HERRING FROM SMOKEHOUSE TO BONING ROOM.
JOHN P. MCCURDY SMOKEHOUSE, LUBEC. 1984.
PHOTOGRAPH BY LYNN KIPPAX, JR.

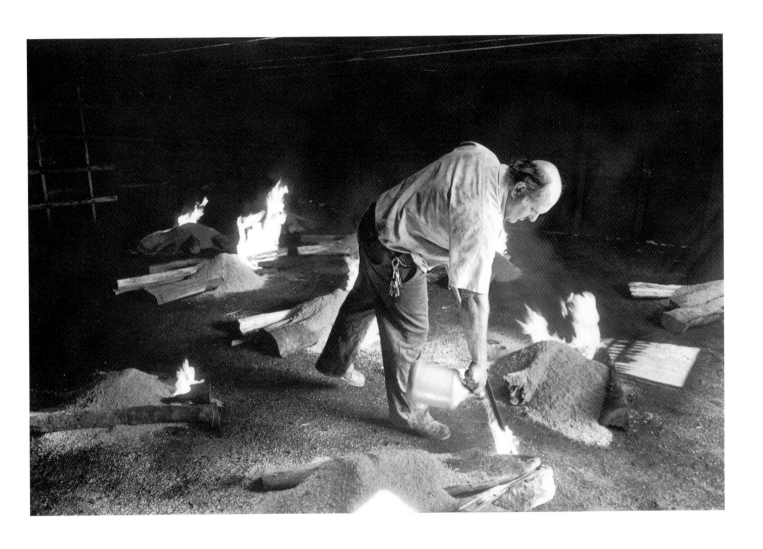

"I'M THE ONLY one who has a trade like this. I'm the only one can go around and light fires and not get arrested. You can call me a legalized arsonist." Richard Munson, smoketender. He is one of two men who hang the herring above the fires in the smokehouse bays.

ABOVE: RICHARD MUNSON LIGHTING SMOKE FIRES WITH KEROSENE INSIDE HERRING SMOKEHOUSE.
JOHN P. MCCURDY SMOKEHOUSE, LUBEC. 1984. PHOTOGRAPH BY SCOTT VLAUN.
OVERLEAF: CULLING ISLAND SHEEP. LEFT TO RIGHT, DONNA KAUSEN, JENNY CIRONE, AND DEAN CIRONE.
GREAT NASH ISLAND, SOUTH ADDISON. 1984. PHOTOGRAPH BY LYNN KIPPAX, JR.

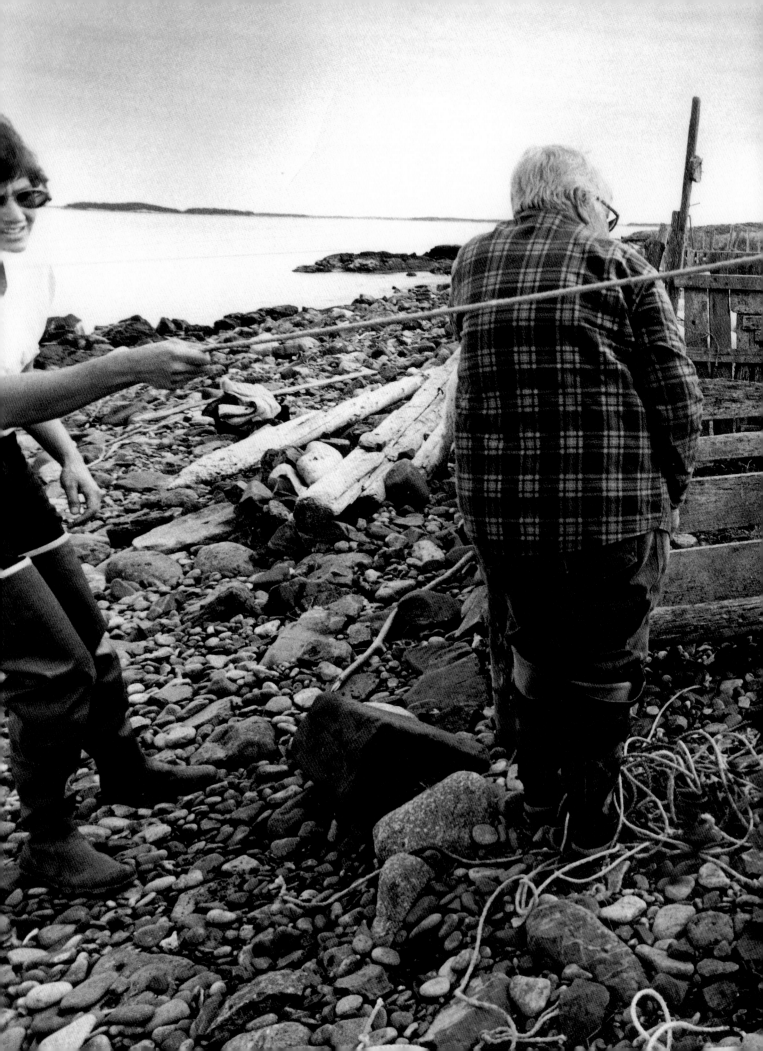

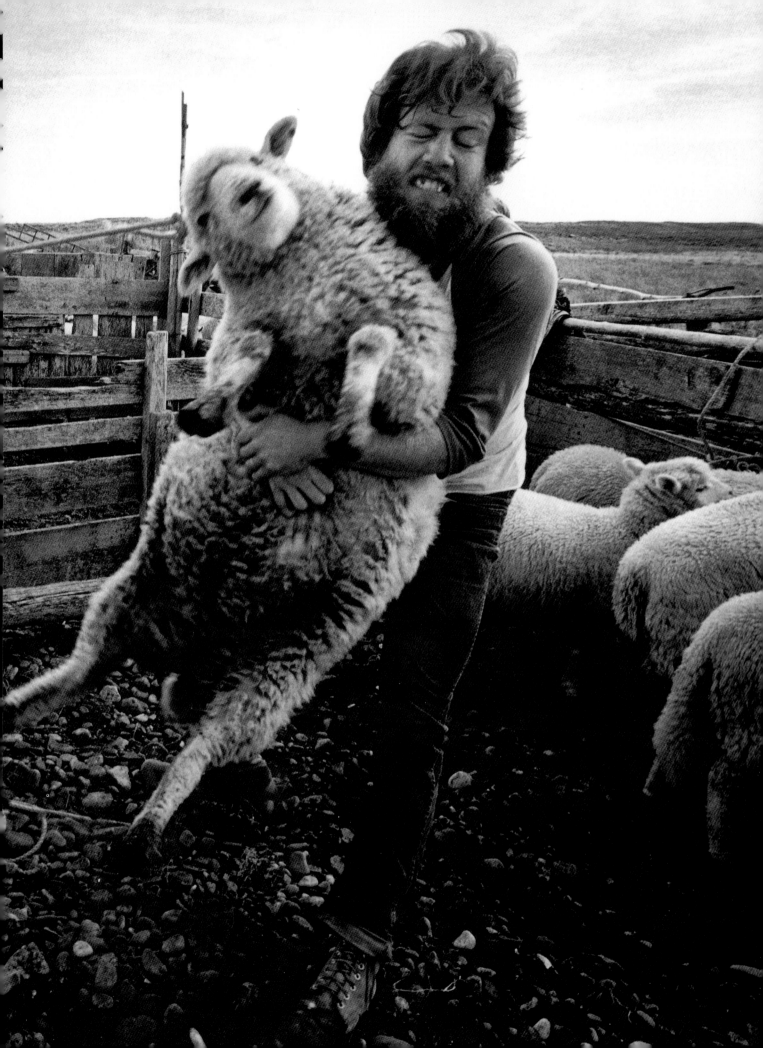

THE PORTLAND fish Exchange, an open display auction begun in 1986, changed the way fish were bought and sold in the United States. No longer were fish traded sight unseen, but for all to see. Goals were better prices, higher quality fish, and a larger volume of fish landed in Maine.

PORTLAND FISH EXCHANGE. LEFT TO RIGHT: JOHN ALFIERO, MIKE ALLEN, AND SAM TUCK, BUYERS. PORTLAND, 1992.
PHOTOGRAPH BY AYUMI HORIE.

"WE'D LOOKED at Maine before, but the marketing wasn't any good, couldn't sell your fish here, the prices weren't good. Then the Fish Exchange was up and running and so we came up and gave it a try and liked it with all of its warts." Barbara Stevenson, fish seller, boat owner.

PORTLAND FISH EXCHANGE. RIGHT: BARBARA STEVENSON, FISH SELLER; LEFT, MIKE ALLEN, FISH BUYER. PORTLAND, 1992.
PHOTOGRAPH BY AYUMI HORIE.

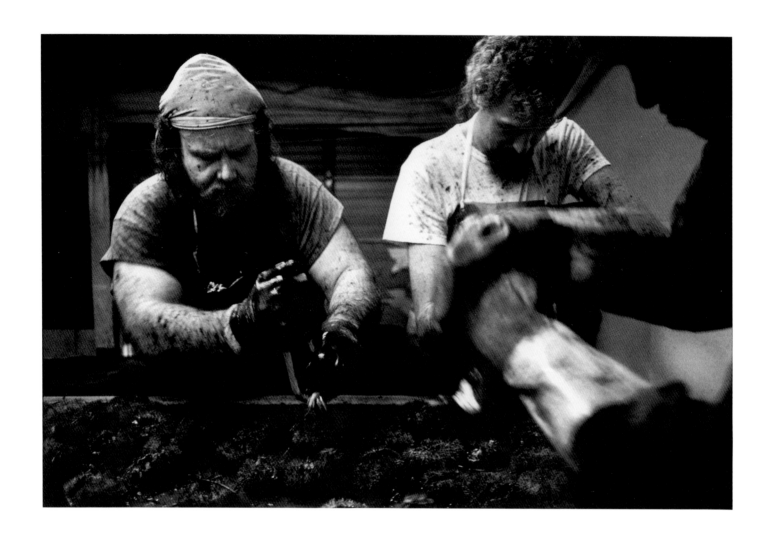

ATCHAN TAMAKI is the biggest sea urchin processor in Maine. In the height of the season more than 200 workers pick the roe from upward of 2,000 totes of urchins each day harvested by 300 urchin divers. In 1993 urchins were first in volume, third in value in Maine's fishing industry.

CRACKING SEA URCHINS OPEN FOR THEIR ROE. I.S.F. TRADING COMPANY, HOBSON'S PIER, PORTLAND. THE TWO MEN LIVE IN A HALF WAY HOUSE. 1993. PHOTOGRAPH BY DAVID GAVRIL.

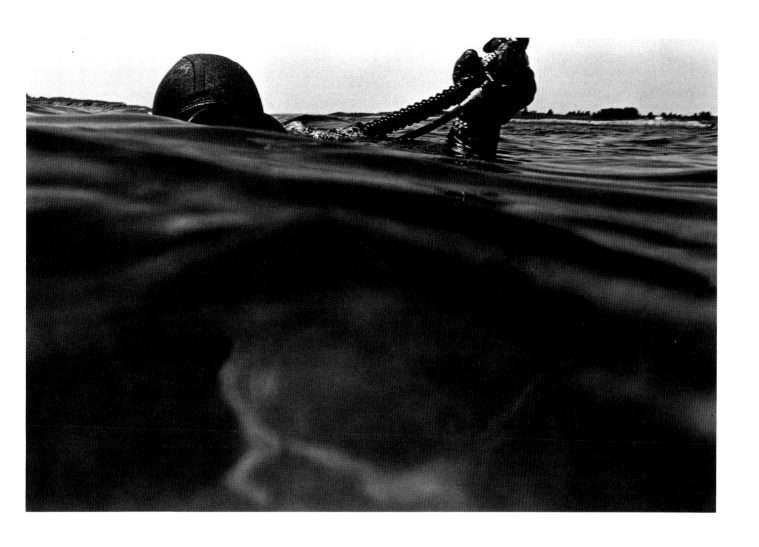

"*THIS IS ONE FISHERY where you got more non-fishermen than fishermen out there. Okay, because of the diving. There are people now, they can grab anything that floats, they got it on the water trying to harvest urchin. It really has become a circus.*" *Paul Blais, urchin buyer.*

ANDY MZRACK, SEA URCHIN DIVER, IN CASCO BAY NEAR MINK ROCKS, OFF OF PORTLAND. 1993.
PHOTOGRAPH BY ANDREE KEHN.

THE COLONY HOTEL in Kennebunkport is one of the last of the
sprawling hotels that once rode the coast like ships, catering to guests who
came for the summer. For over 75 years it has lorded over Cape Arundel,
oblivious to the day trippers now inundating other parts of town.

CHANGING BED LINENS IN GUEST ROOM AT THE COLONY HOTEL, KENNEBUNKPORT. 1987.
PHOTOGRAPH BY KEN KOBRE.

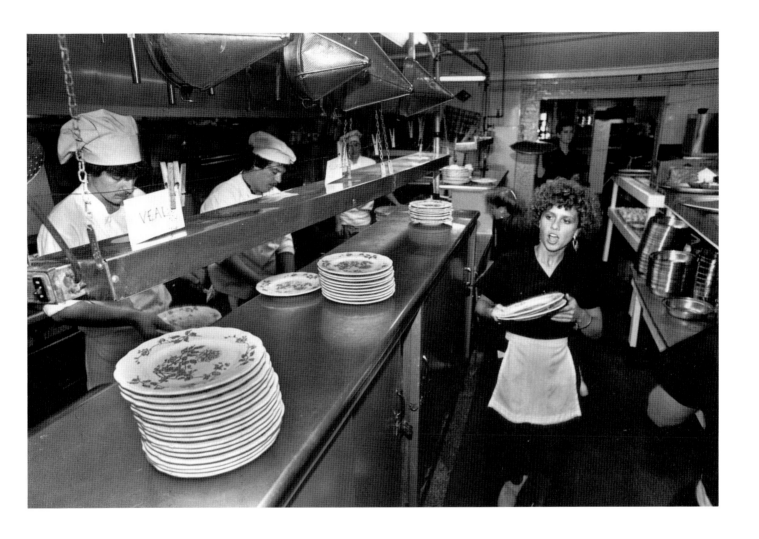

"THE MEN used to wear dinner jackets. The women were always in . . . almost gowns for dinner. There was an abundance of jewelry and the people who were staying up here at the hotel were a very wealthy clientele." Karen Walker who by 1987 had come to the Colony for 17 summers.

ABOVE: WAITRESSES PICKING UP FOOD ORDERS IN KITCHEN FOR DINING ROOM.
COLONY HOTEL, KENNEBUNKPORT. 1987. PHOTOGRAPH BY KEN KOBRE.
OVERLEAF: THE PIER, ESTABLISHED IN 1898. OLD ORCHARD BEACH. 1994. PHOTOGRAPH BY JOSEPH LEE.

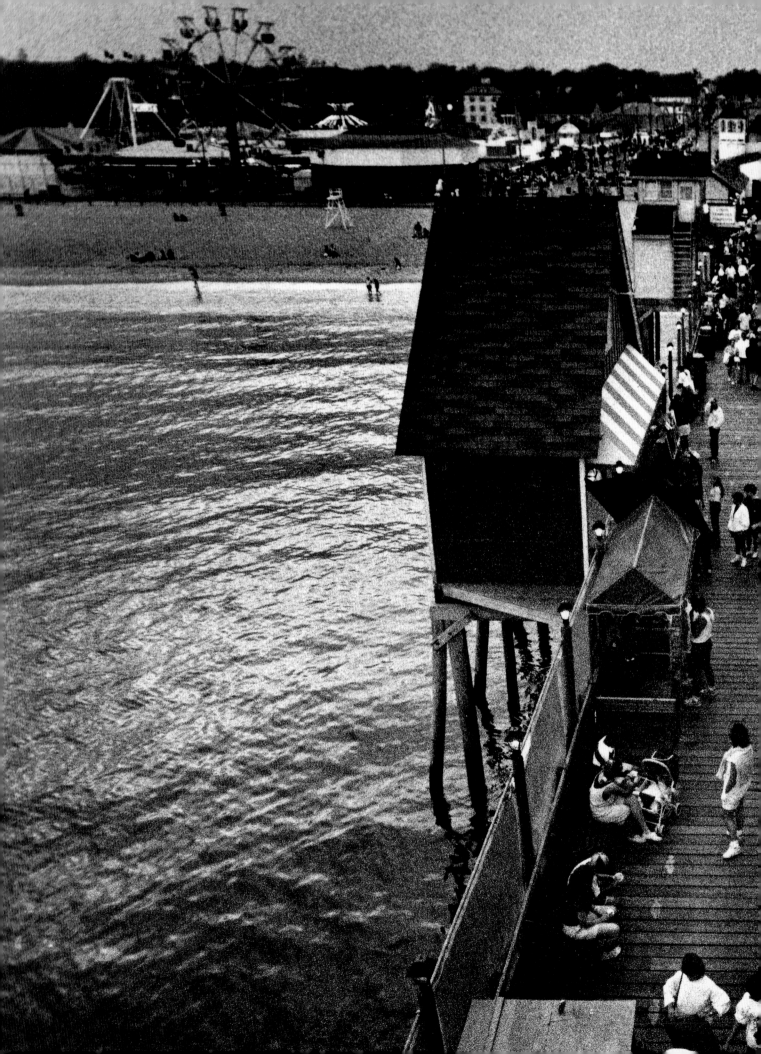

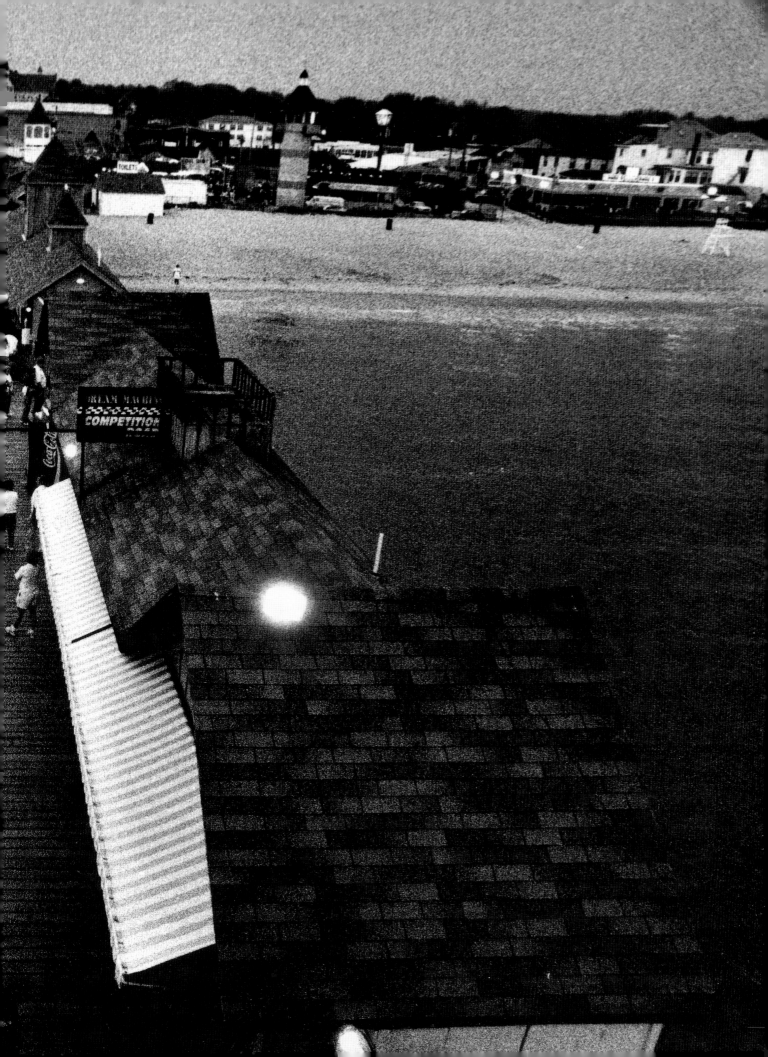

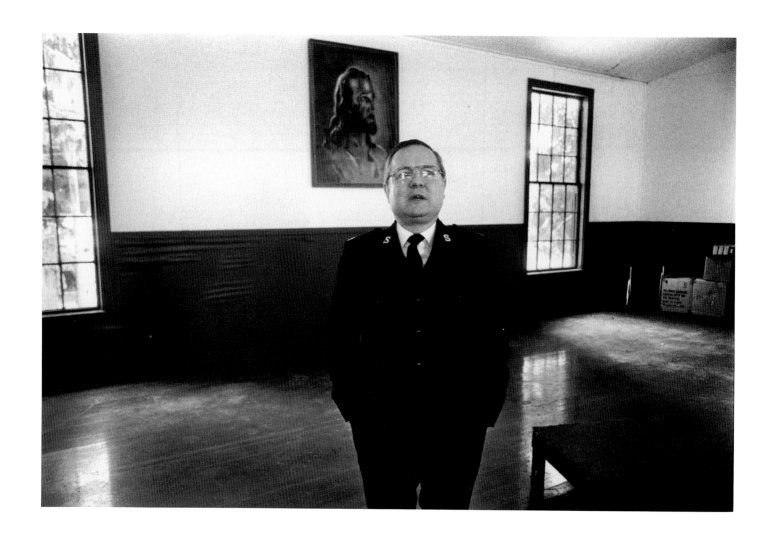

OLD ORCHARD BEACH swells to a population of 100,000 in the summer, shrinks to 10,500 in the winter. Sixteen of seventeen gift and clothing stores may close, but Toni Ladakakos' beauty shop stays open. The Salvation Army band plays right through the winter .

MAJOR RANDALL DAVIS OF THE SALVATION ARMY CORPS IN THE TABERNACLE. OLD ORCHARD BEACH, WINTER, 1990.
PHOTOGRAPH BY ROBYN REDMAN.

TONI LADAKAKOS, YEAR ROUND OWNER AND OPERATOR OF TONI'S BEAUTY SALON. OLD ORCHARD BEACH, WINTER, 1990.
PHOTOGRAPH BY ROBYN REDMAN.

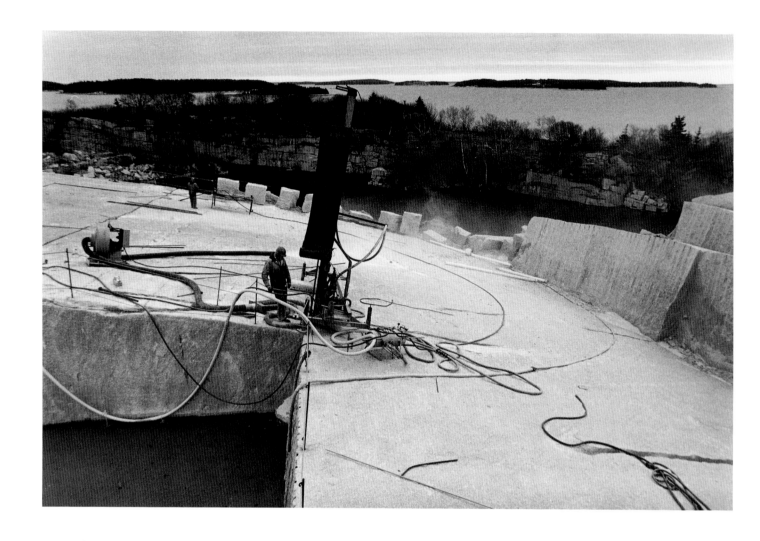

THE STRENGTH of Crotch Island granite— it is in the Brooklyn Bridge and Rockefeller Center Plaza—has kept the last commercial quarry in Maine drilling since the nineteenth century. When cement replaced granite, most of the island quarries became swimming holes.

GRANITE QUARRY OPERATED BY NEW ENGLAND STONE OF RHODE ISLAND. CROTCH ISLAND. 1991.
PHOTOGRAPH BY MARYANNE MOTT.

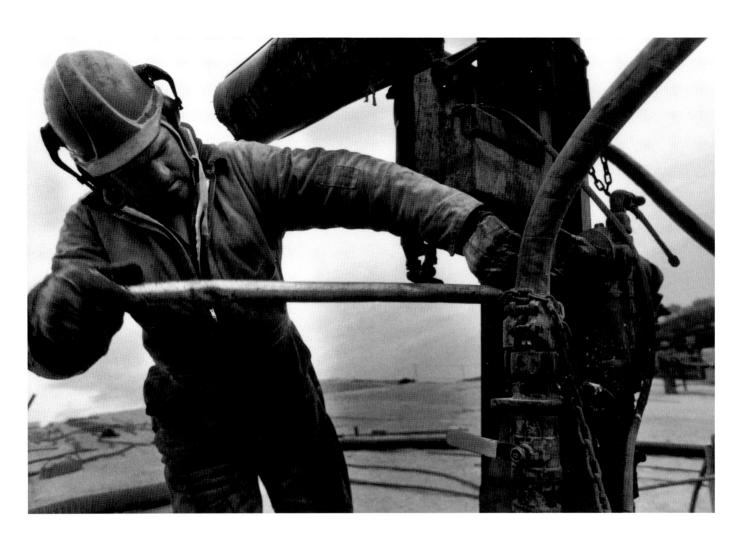

"LAST YEAR we had everything here. We had two compressors, two drilling machines, we had double the crew. We worked eight hours straight all the time. Last year we quarried 100,000 cubic feet. This season, we're just drilling." Benny Oliver, foreman on Crotch Island.

RICHARD STINSON USING DRILL TO ESTABLISH HOLES IN GRANITE FOR CHARGES. CROTCH ISLAND. 1991.
PHOTOGRAPH BY MARYANNE MOTT.

A PROPOSAL by the Pittson Company to site a mammoth oil refinery

on the island city of Eastport pitted Eastporter against Eastporter between

1968 and 1983. Environmentalists talked about oil spills and others talked

about jobs. In 1983 Pittston gave up.

AFTER VOTE BY EASTPORT CITY COUNCILLORS AGAINST RENEWING LEASE OF CITY AIRPORT LAND TO
PITTSTON COMPANY. CITY HALL, EASTPORT. JUNE 3, 1981.
PHOTOGRAPH BY LYNN KIPPAX, JR.

"*I DON'T think that it's going to change too much. Because after 76 years of it, I have seen the time when I thought we would flourish. It flickered right out. I never thought Pittston would amount to anything.*" Helen Huntley of Eastport.

YOUNG BOY IN FRONT OF POOL HALL. WATER STREET, EASTPORT. 1980.
PHOTOGRAPH BY LYNN KIPPAX, JR.

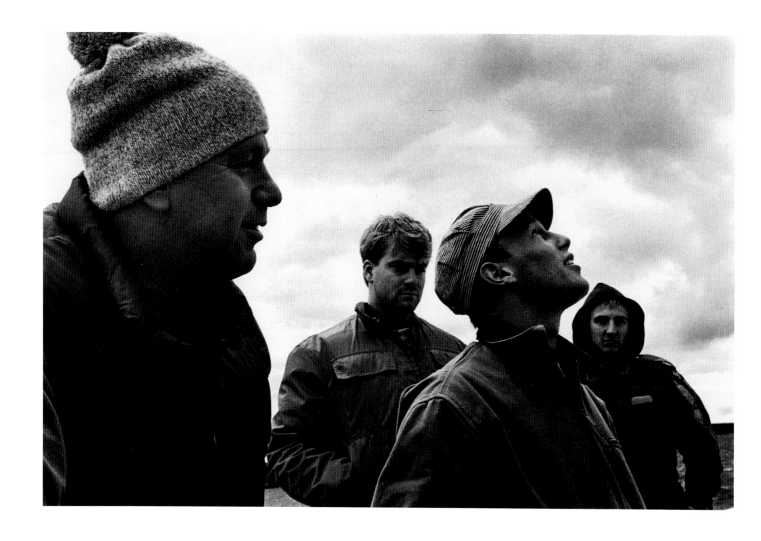

"*I WOULDN'T have ever considered going to Mass. Maritime or the one in Michigan or in Texas. I don't have roots to those places. I have roots here. I want to be another one of the great sea captains from Maine.*"
Frank Wareham, Maine Maritime Academy student, from Belfast.

MAINE MARITIME STUDENTS ABOARD SCHOONER, *BOWDOIN*, OUTSIDE CASTINE. 1991.
PHOTOGRAPH BY JULIA RODRIGUEZ.

M*AINE MARITIME Academy came to the historic coastal village of*
Castine in 1942 to train young people for the merchant marine. For sea
experience, the Academy relies on its 533 foot long State of Maine *vessel*
and the schooner Bowdoin.

SCHOONER, *BOWDOIN,* BELONGING TO THE MAINE MARITIME ACADEMY SAILING OUTSIDE OF CASTINE. 1991.
PHOTOGRAPH BY JULIA RODRIGUEZ.

INLAND

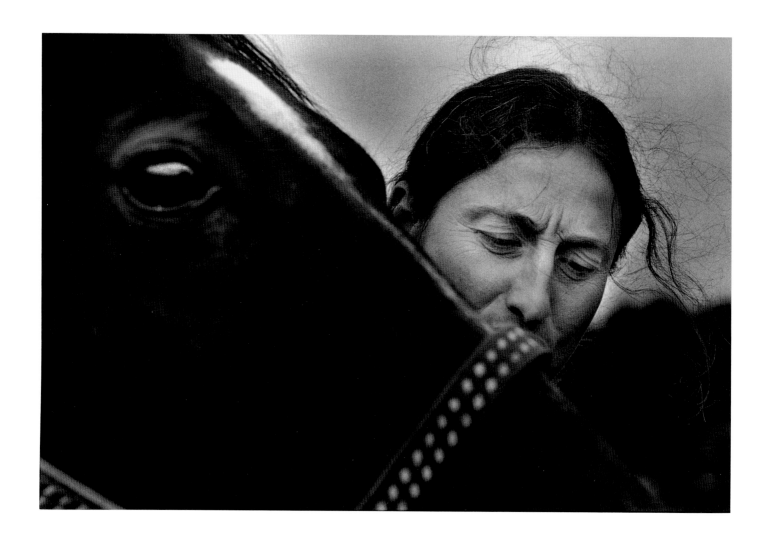

JEAN DEMETRACOPOULOS runs Fox Hill Farm with its 24 sheep, four pigs, 12 horses (eight are boarders, four her own), a dozen turkeys, a large vegetable and fruit garden and eight acres of hay fields. Just the kind of farming she feels Maine's future holds.

JEAN DEMETRACOPOULOS WITH ONE OF THE HORSES AT HER FOX HILL FARM. SOUTH BERWICK. 1992.
PHOTOGRAPH BY R. TODD HOFFMAN.

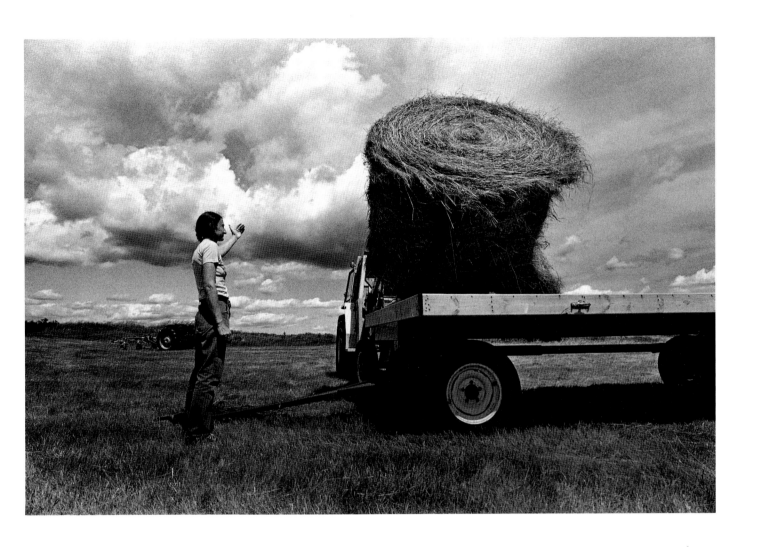

"THE BACKYARD FARMS . . . are keeping the bulk of open space open at this point in time. Farming isn't dead in New England. It's just reverting back to the way it was 150 years ago, where people grew their own and sold their surplus." Jean Demetracopoulos.

JEAN DEMETRACOPOULOS HAYING NEAR FOX HILL FARM. SOUTH BERWICK. 1992.
PHOTOGRAPH BY R. TODD HOFFMAN.

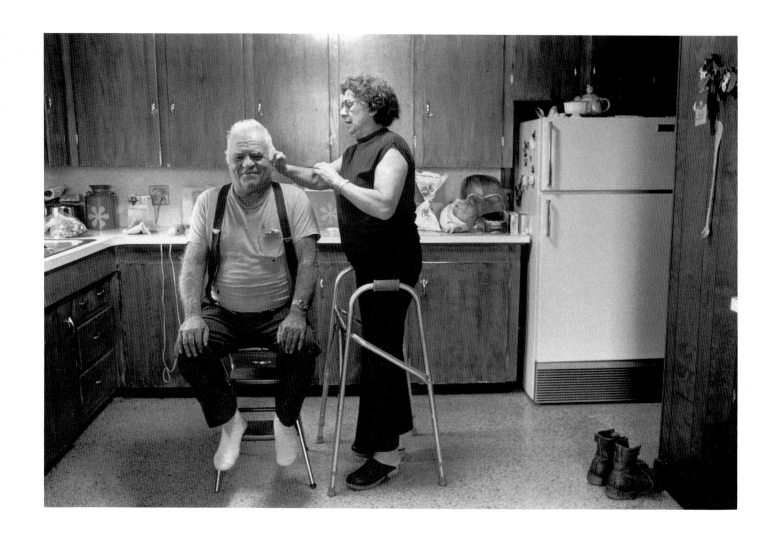

*FRED AND THELMA Rancourt need help running their dairy farm.
With 140 cows, it is the largest of five left in Vassalboro—there were 18
when they bought it in 1943. They can't afford to pay hired hands for
working 80 hours a week. So they give them housing and $150 a week.*

THELMA RANCOURT GIVING HER HUSBAND, FRED, A HAIRCUT IN THE KITCHEN OF THEIR FARMHOUSE.
RANCOURT DAIRY FARM, VASSALBORO. 1987.
PHOTOGRAPH BY PAM BERRY.

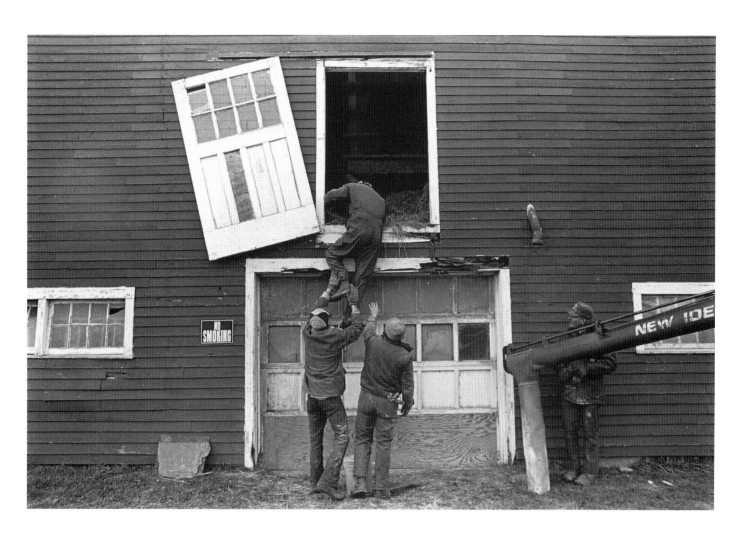

"*If you watch a farmer, you won't want to be a farmer. Farm you gotta be there every day. You got to be up four-thirty. Get done when you get done. 'Course it ain't hard work a lot of it. Working out I can get a couple of days off. Here I can only get one.*" Ralph Linkletter, farm hand.

RALPH LINKLETTER AND ANDY STEWART HELPING BRIAN LAJOIE UP TO THE HAYLOFT. BOBBY RANCOURT LOOKS ON.
RANCOURT DAIRY FARM, VASSALBORO. 1987.
PHOTOGRAPH BY PAM BERRY.

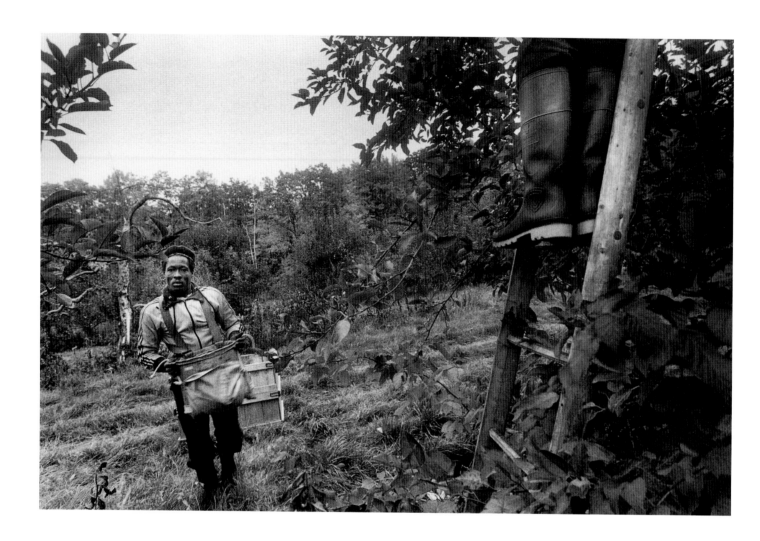

ABOUT 450 Jamaicans come to Maine for six weeks to harvest apples, doing work that Mainers once did. The first were brought into Maine in 1971. In 1988, thirteen Jamaicans along with one local worked picking apples at Tom Gyger's Douglas Hill orchard.

JAMAICAN APPLE PICKERS. DOUGLAS HILL ORCHARD, SOUTH BRIDGTON. 1988.
PHOTOGRAPH BY TONEE HARBERT.

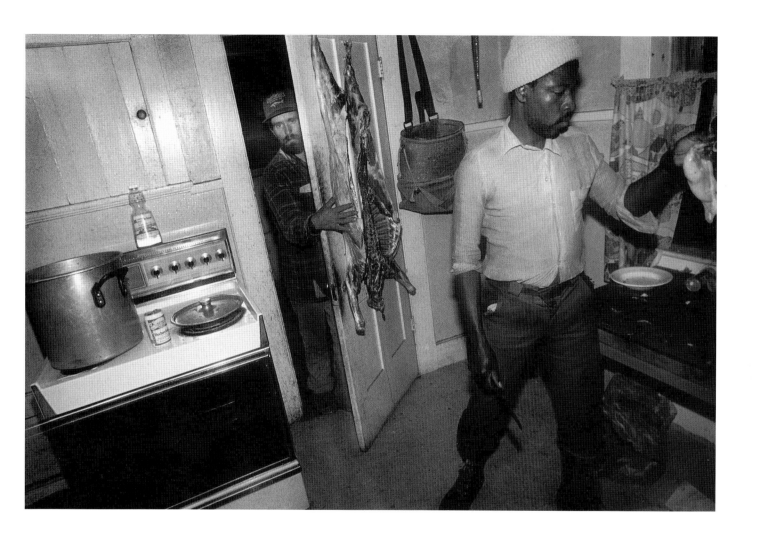

"*I CAN work with Tom if he needs me until I'm 70 years old. God has*
helped me with health and strength. I work very hard, and I feel at home,
and I know that my family is okay." Erroll, Jamaican, who has picked
apples for Tom Guyger at Douglas Hill for 12 seasons.

ABOVE: DOUGLAS HILL ORCHARD, SOUTH BRIDGTON. 1988. PHOTOGRAPH BY TONEE HARBERT.
OVERLEAF: JAMAICAN APPLE PICKERS. DOUGLAS HILL ORCHARD, SOUTH BRIDGTON. 1988. PHOTOGRAPH BY TONEE HARBERT.

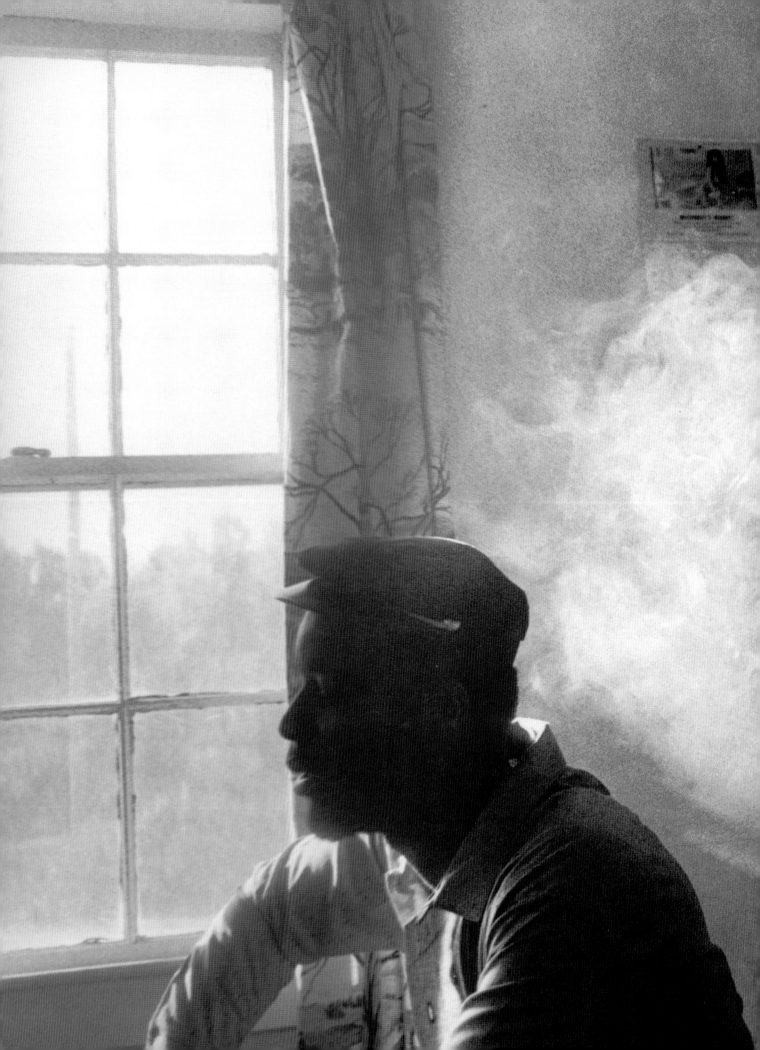

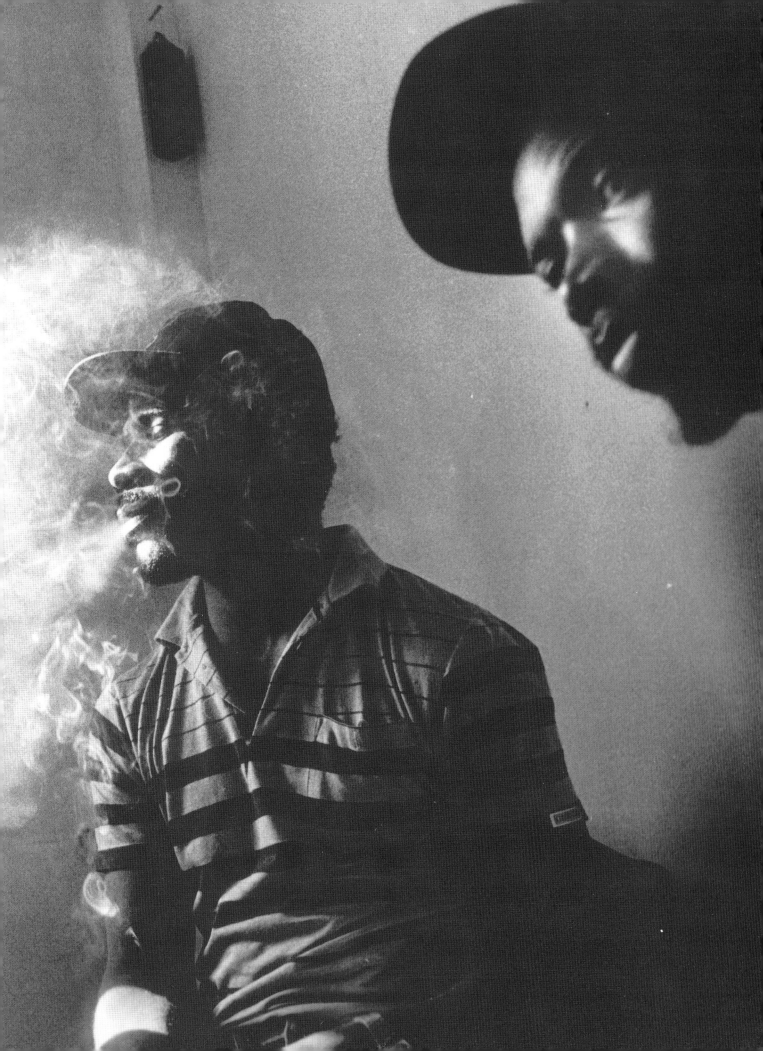

In THE SPAN of 12 years, the number of commercial dairy farms in Maine dropped by over half—from 1,837 in 1978 to 832 in 1992. The trend continues. Against this background, the Russells bought their 200 acre farm in 1980, beginning with 20 milking cows. They're still at it.

Outside the cow barn at five o'clock in the morning. Russell Jersey dairy farm, Litchfield. 1990.
Photograph by Cay Chalker.

"*ANY DAIRY FARM, not just mine, is not likely to be successful in terms of business. The only way to get the equity out is when you sell. So you have to change the question to 'What is a successful way of life?'"* *Mark Russell, dairy farmer.*

VICKI RUSSELL WITH HER DAUGHTER, ANGELINA, AGE TWO. RUSSELL JERSEY DAIRY FARM, LITCHFIELD. 1990.
PHOTOGRAPH BY CAY CHALKER.

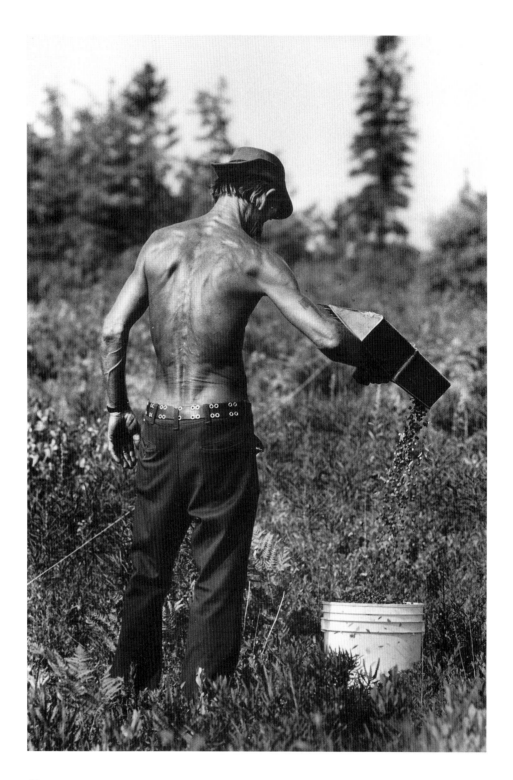

IN THE SUMMER of 1985, two thousand rakers toiled to harvest

45 million pounds of wild blueberries. Mechanical harvesters threatened

the end for hand raking. It was an empty threat.

CHARLIE TORREY, BLUEBERRY RAKER, GOULDSBORO. 1985.
PHOTOGRAPH BY LYNN KIPPAX, JR.

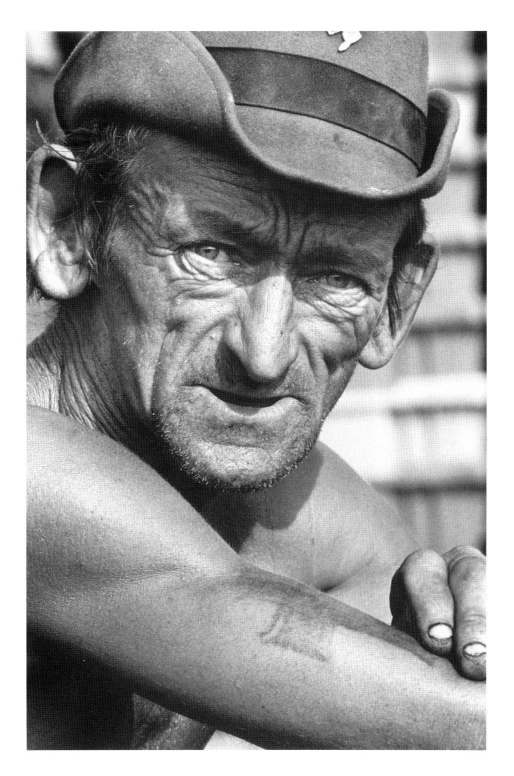

"I DON'T WORK it too hard. I was born '41 and I went down on the blueberry barrens with Leslie Randall in 1942. I try to make the same amount a day as I can make when I'm clammin'." Charlie Torrey.

CHARLIE TORREY, BLUEBERRY RAKER, GOULDSBORO. 1985.
PHOTOGRAPH BY LYNN KIPPAX, JR.

PIECING together a year's work is a way of survival for many rural Mainers. Some of this and then some of that. For the Bubiers in Washington County that means cutting wood, welding, repairing cars, herring fishing and when all else fails, public assistance.

ERVINS BUBIER WORKING ON HIS WOODS TRUCK ALONG WITH HIS SON, TOMMY. PERRY. 1987.
PHOTOGRAPH BY PAM BERRY.

*"Y*OU CAN'T *run away from your troubles. They keep right up to ya.*
See, if you tip over the wood trailer today, you can't clap your hands and
say, 'I'll see you tomorrow.' If the skidder breaks down, you fix what ails it
and keep right on going." Ervins Bubier.

ABOVE: ERVINS BUBIER, JR., WATCHING TELEVISION IN HIS FAMILY'S HOME. PERRY. 1987. PHOTOGRAPH BY PAM BERRY.
OVERLEAF: TOMMY, ERVINS JR. AND DONNA BUBIER IN THE FAMILY HOME. PERRY. 1987. PHOTOGRAPH BY PAM BERRY.

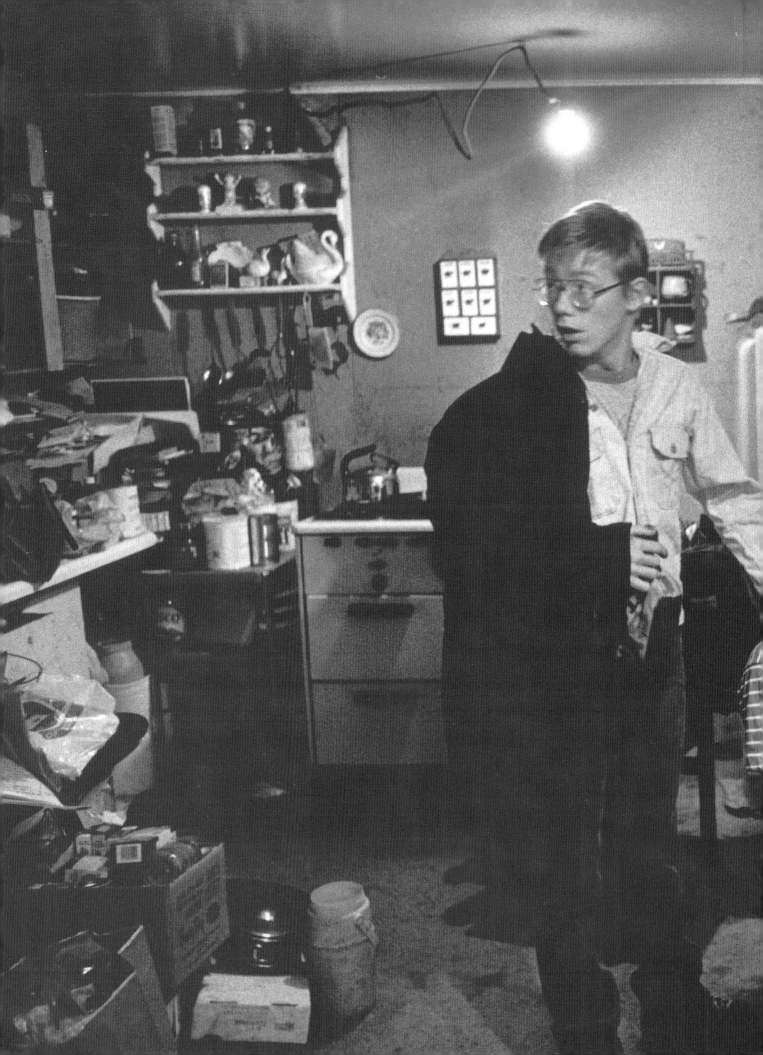

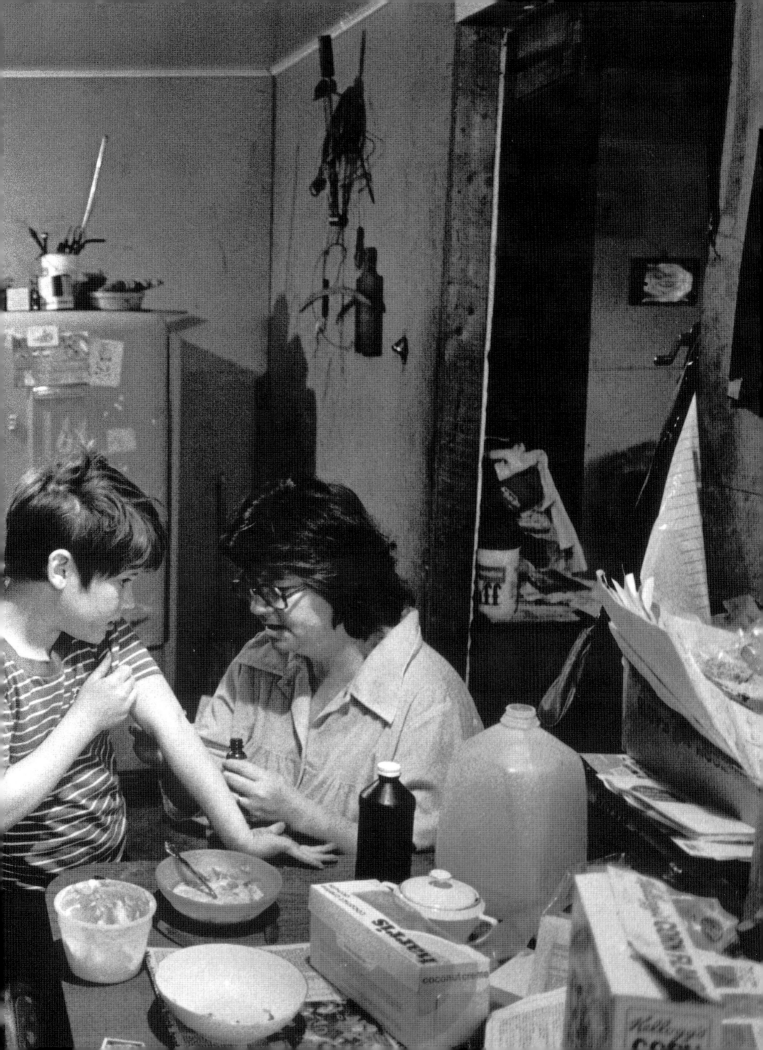

NORRIS and Marina Davis moved to Maine in 1981. They bought a 27 acre field, built a home and made a farm. They live as simply and self-sufficiently as they can. They are part of a vast influx of "back-to-landers" who have come to Maine and are changing the state with their ideas.

ANDREW DAVIS, AGE NINE, AT HIS FAMILY'S FARM, SUGAR HILL ROAD. HARMONY. 1993.
PHOTOGRAPH BY PHIL GRANT.

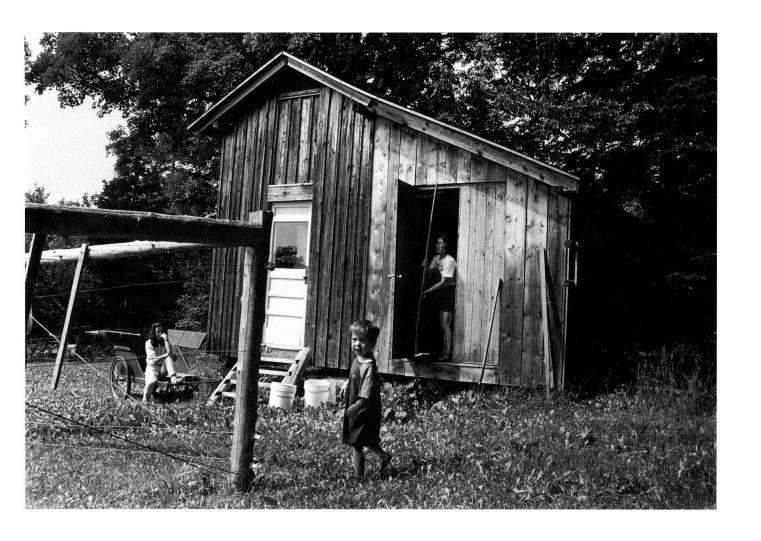

"WE DON'T live a nineteenth-century lifestyle in a twentieth-century world. We live a life of ecological awareness. If we wanted to go backwards, we wouldn't use fiberglass insulation, solar lights, car, chainsaw or anything." Marina Davis.

LEFT TO RIGHT: AUDREY DAVIS, AGE FOURTEEN, WILLIAMS DAVIS, AGE THREE, WITH THEIR MOTHER, MARINA DAVIS. BY THE TOOLSHED, SUGAR HILL ROAD. HARMONY. 1993. PHOTOGRAPH BY PHIL GRANT.

WITHDRAWN

SCCCC - LIBRARY
4601 Mid Rivers Mall Drive
St. Peters, MO 63376

"*I DON'T THINK Eric's abandoned his original beliefs. I just think he's realized we have to find a way to also make a living. We can't just go out there and commune with nature. Now he's much more of a businessman.*"
Ann Brandt-Meyer on changes in farming that her husband made.

ERIC BRANDT-MEYER WORKING AT COMPUTER. GOOD EARTH FARM. FREEPORT. 1991.
PHOTOGRAPH BY MICHELLE LAMBERT.

ERIC AND ANN Brandt-Meyer came to Maine in 1984 when they were in their mid-twenties. Eric wanted to farm organically. Realities of making a living pushed the farm into dried flowers, Christmas trees, hay rides and limited use of chemical pesticides. Ann had to work outside the farm.

ERIC BRANDT-MYER HARVESTING LARKSPUR. GOOD EARTH FARM. FREEPORT. 1991.
PHOTOGRAPH BY MICHELLE LAMBERT.

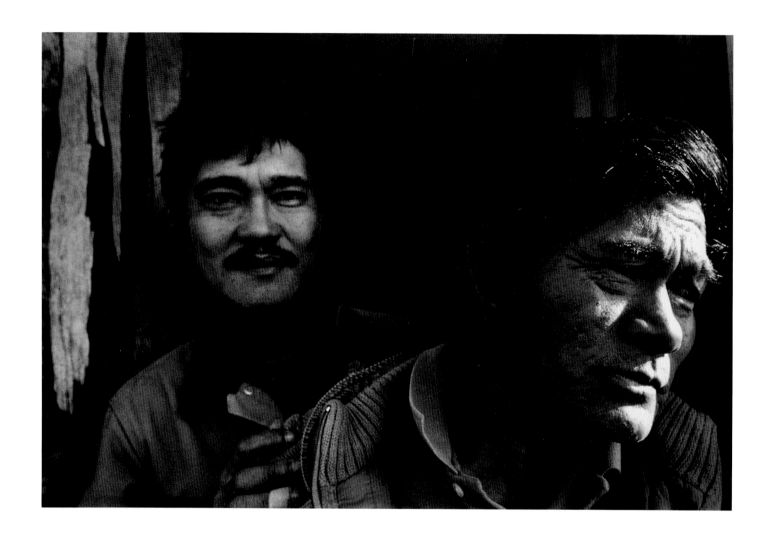

"WE COME *so far to work for a little while, so we take whatever's there*
for us. And we make the best of it and make it a home. And once you get
through the season you look back and you go, 'Hey we made it again.'"
Gustavo Solis, foreman at Maine Packers' broccoli processing plant.

JUNE AND ARTHUR, MIGRANT LABORERS FROM THE PHILIPPINES, AT CAMP HOUSING
FOR H. SMITH PACKING BROCCOLI FARM. LIMESTONE. 1992.
PHOTOGRAPH BY AMY TOENSING.

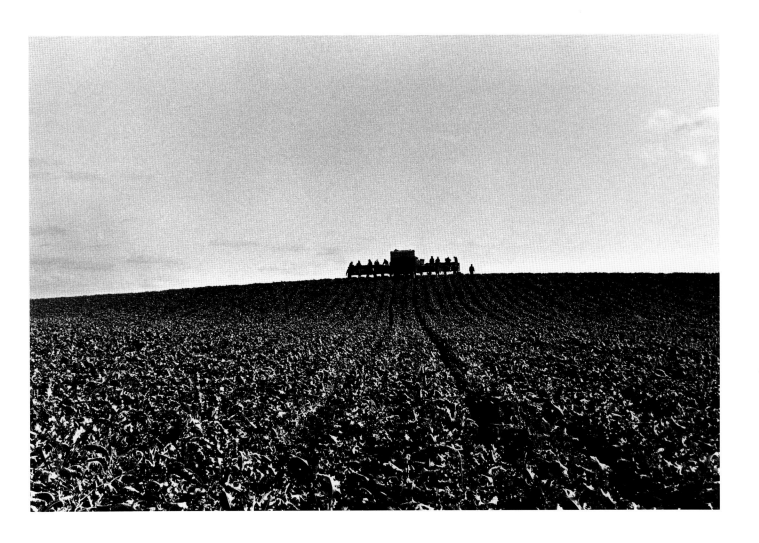

FROM the first experiments in 1982 to grow broccoli in northern Maine, came a niche crop on 3,000 acres in 1992. For the four month harvest, the growers depend on 350 migrant workers from the Philippines, Mexico and Texas. Locals will harvest potatoes, but they won't hand cut broccoli.

Broccoli harvest. Last day in the field. H. Smith Packing broccoli farm. Limestone. 1992.
Photograph by Amy Toensing.

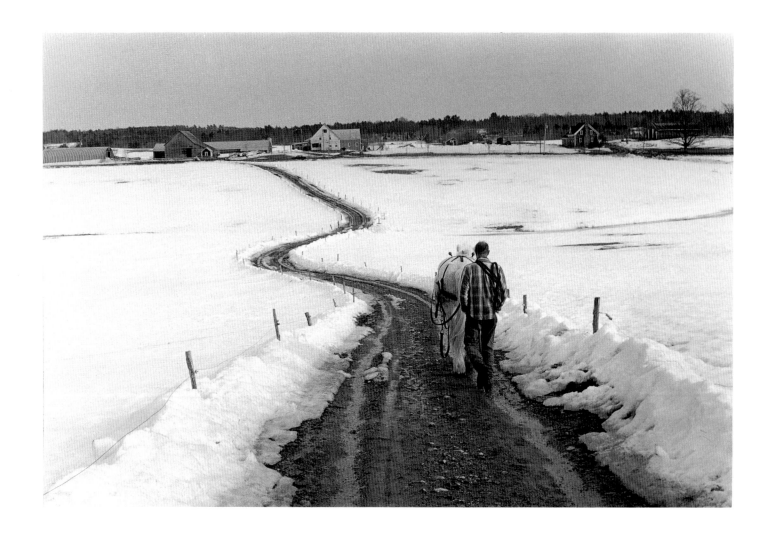

MAPLE SUGARING marks the warming of early spring, a job that helps piece together a year of work. On his farm in Whitefield, Austin Moore, along with Mark Fenderson, has been tapping sugar maples for over 20 years. They produce nearly 100 gallons of maple syrup each year.

AUSTIN MOORE WALKING HOME IN THE LATE AFTEROON FROM HIS SUGAR HOUSE ON MAINE MAPLE SUNDAY. WHITEFIELD. 1993.
PHOTOGRAPH BY DAVID GAVRIL.

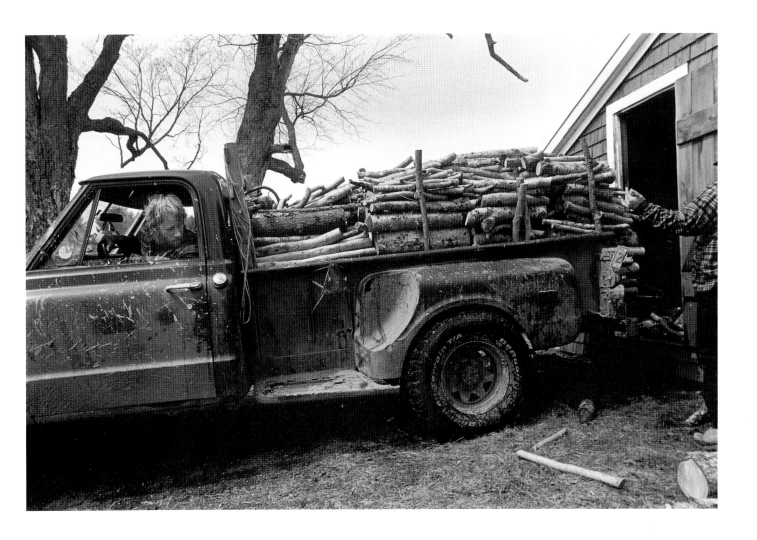

"WE do it mostly in March and March is a time of year where you don't do much else on the farm. It's kind of in-between seasons and so it fit in pretty good, really didn't have to neglect other things to be able to do it." Austin Moore describing his maple sugaring operation.

GETTING WOOD FROM AUSTIN'S WOOD PILE FOR MAPLE SUGARING OPERATION. WHITEFIELD. 1993.
PHOTOGRAPH BY DAVID GAVRIL.

WORK

"*I BEEN SITTING in the same seat for two years. If you're not here,*

you're always wondering who's sitting in your seat." *Rick Aspinall,*

L.L. Bean telemarketing assistant team leader. Between 1982 and 1992,

service jobs outstripped manufacturing jobs for the first time in Maine.

L. L. BEAN TELEMARKETING CENTER IN THE FORMER PECK'S DEPARTMENT STORE BUILDING. LEWISTON. 1990.
PHOTOGRAPH BY TONEE HARBERT.

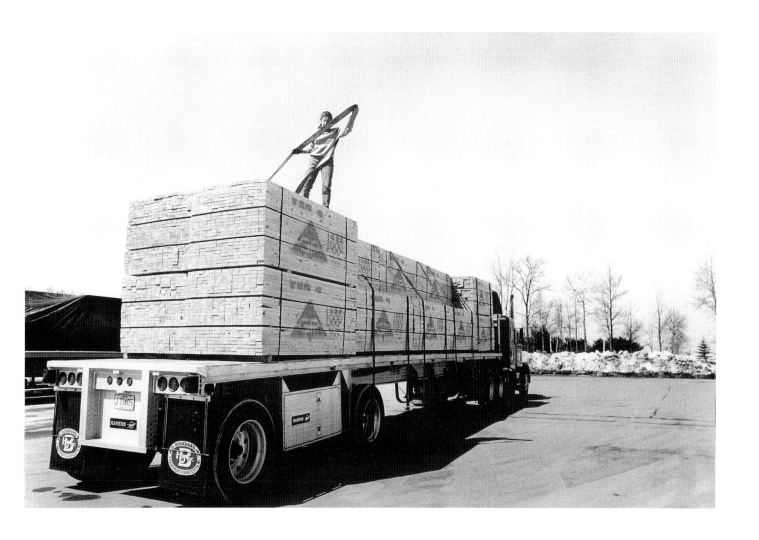

"SOME WOMEN CAN get real militant about their 'sexual equality thing.' I've learned when to be graceful and accept assistance, whether I need it or not! You shouldn't be askin' for special favors, either. That means figuring out how to do it on your own." Kendra Cole, trucker.

KENDRA COLE, INDEPENDENT OWNER-OPERATOR, LOADING HER TRUCK. 1992.
PHOTOGRAPH BY NOREEN HOGAN.

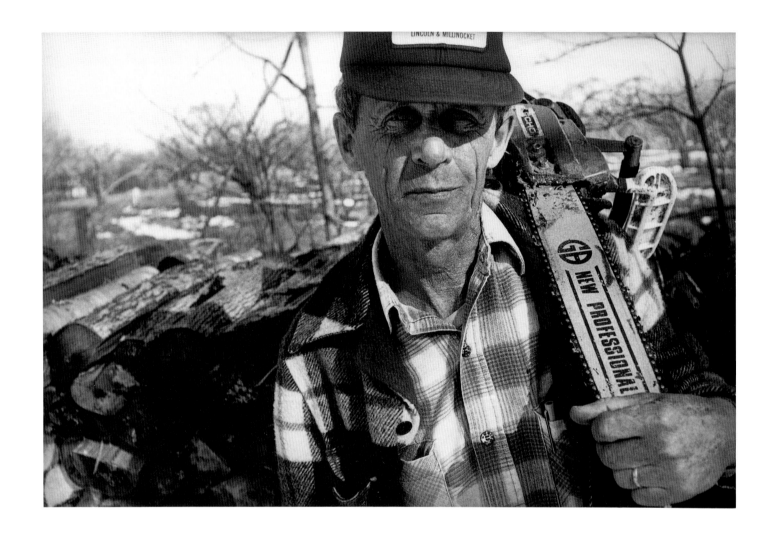

"Walkin' in the woods 20 miles to go to work, Christ, and stayin' there two and three months, that's pod auger days. No electricity! No running water! After you'd get there, Christ, they'd work ya, Jesus Christ, from dark to dark." Nelson LeVasseur on cutting wood in the 1930s.

Norman LeVasseur who worked in the woods for the Great Northern Paper Company all his life. Ellsworth. 1989.
Photograph by Tonee Harbert.

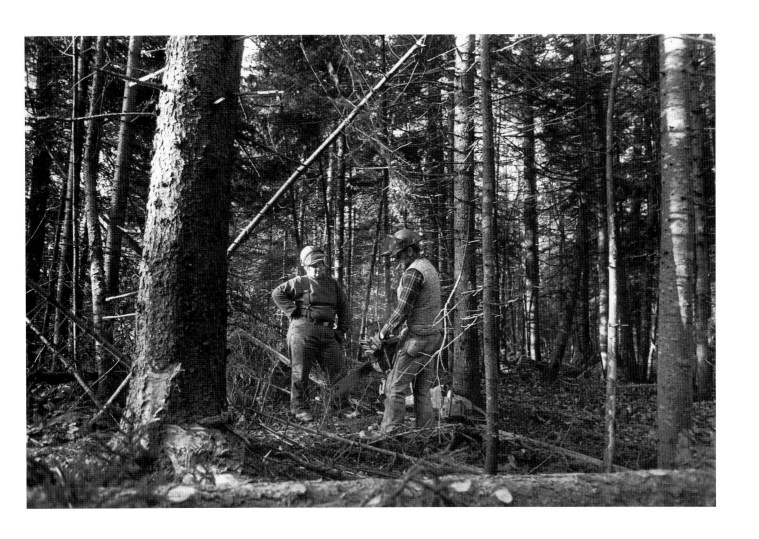

"I LIKE it best when the temperature is around zero to negative ten. That is the best for workin'. Ya don't sweat too much and ya don't have to limb your pines 'cause it's so cold they just break off." Clyde Brown who works with his wife, Donna, cutting wood for a living.

DONNA AND CLYDE BROWN, LOGGERS. NEAR RANGELEY. 1992.
PHOTOGRAPH BY CHRIS DARDARIS.

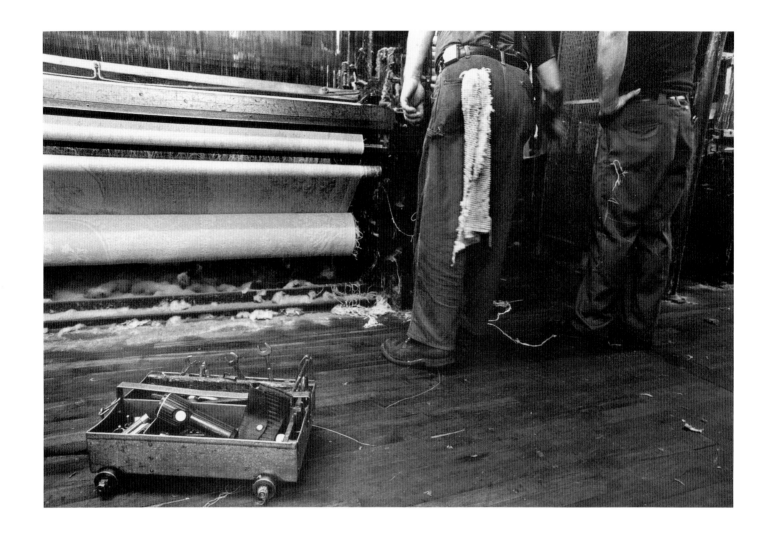

BATES FABRICS textile mill in Lewiston employed over 2,000 in five mills in 1900. In 1989, fewer than 150 in one mill. Then a New Mexico company searched the country for a mill that could weave Pueblo design blankets on jacquard looms. They found the weavers to do it at Bates.

BATES FABRICS TEXTILE MILL, LEWISTON. 1992.
PHOTOGRAPH BY R. TODD HOFFMAN.

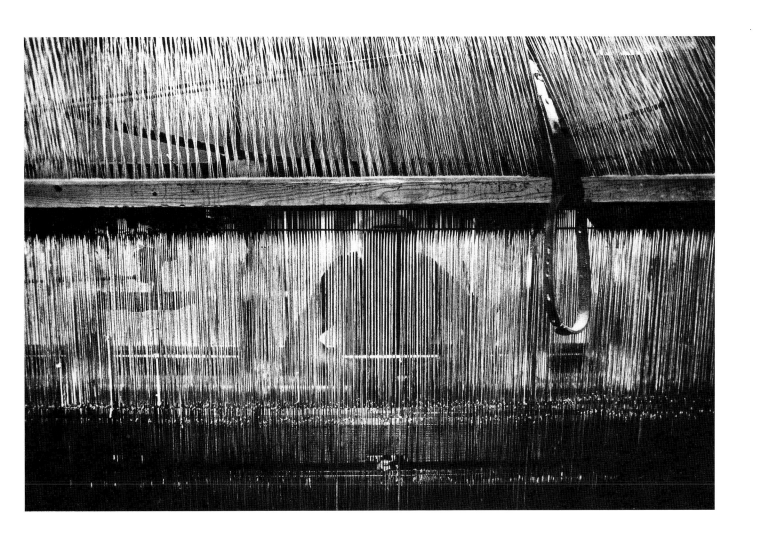

"WHEN I have time, I used to learn with the weavers. I was bobbin boy, I try to hurry, try to learn the trade between the hours. Some people say, it take you about three to six months, but it take about three to four years to be a jacquard weaver." Real Perreault, master weaver, Bates Fabrics.

ABOVE: BATES FABRICS TEXTILE MILL, LEWISTON. 1992. PHOTOGRAPH BY R. TODD HOFFMAN.
OVERLEAF: RAY OUELLETTE TENDING A JACQUARD LOOM. BATES FABRICS TEXTILE MILL, LEWISTON. 1992.
PHOTOGRAPH BY R. TODD HOFFMAN.

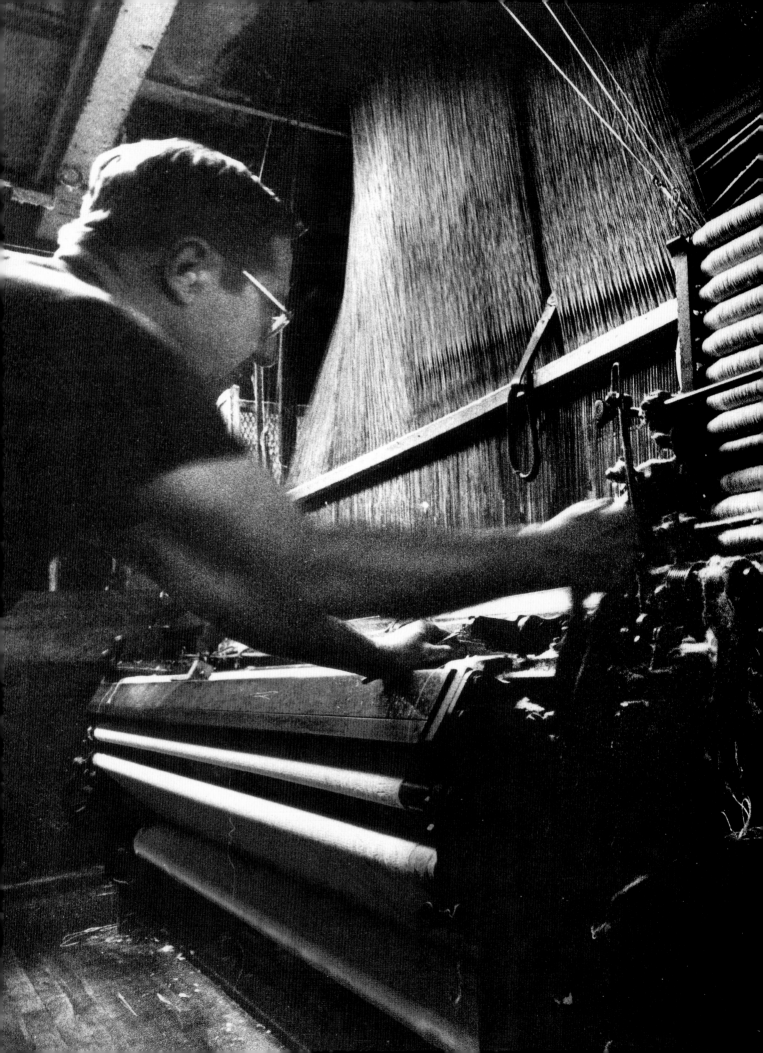

MARY TOFT Walton, born in Lubec, taught over 40 years in South Portland before she retired in 1980. Retirement was not inactivity—she wrote, researched, collected. When she retired, women were breaking outside their traditional work roles of teaching, nursing and the home.

MARY TOFT WALTON, RETIRED SCHOOL TEACHER, IN HER GRAY STREET APARTMENT. PORTLAND. 1991.
PHOTOGRAPH BY KAYCIE LEVY.

MONICA WAS single, unemployed and on welfare. For three years she lived in a school bus with her daughter. "I had a choice to make." A low-paying job, day care for her children and no health care—or the school bus and welfare. She chose the bus. Then she built a house in the woods.

MONICA IN NOVEMBER, 1987. HER SON WAS BORN IN DECEMBER.
PHOTOGRAPH BY PAM BERRY.

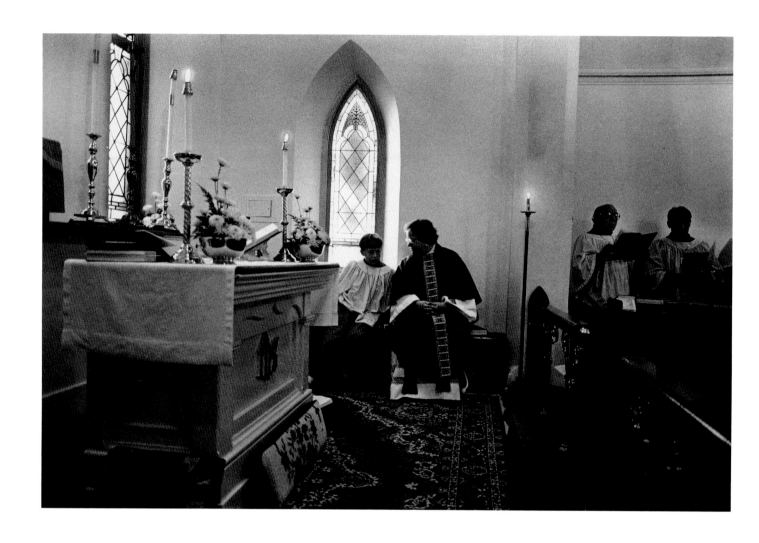

"*I HAVE two or three in the diocese who are real sexist pigs. I have dealt with it, because I won't put up with that sort of stuff. I go to the Bishop. I refuse to allow any of those clergy to mistreat me any more.*" Nancy Platt, one of 127 women ministers in Maine, 12 percent of the total.

NANCY PLATT, EPISCOPAL MINISTER. ST. MATTHEW'S EPISCOPAL CHURCH, HALLOWELL. 1991.
PHOTOGRAPH BY ERIN MILLER.

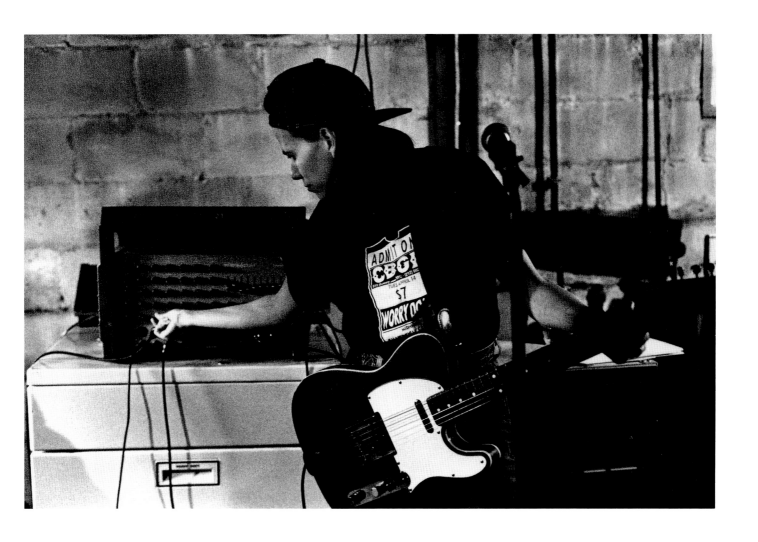

"*If you can do it, they'll take you seriously. If you make a mistake or if you're nervous or you have lousy material, they'll just jump on you and dismiss you because you're female. Whereas with guys, I don't think it's quite that judgmental.*" *Chris Horne of the all girl band, the Brood.*

CAROL BLACKNEY. SCARBOROUGH. 1993.
PHOTOGRAPH BY ANDREE KEHN.

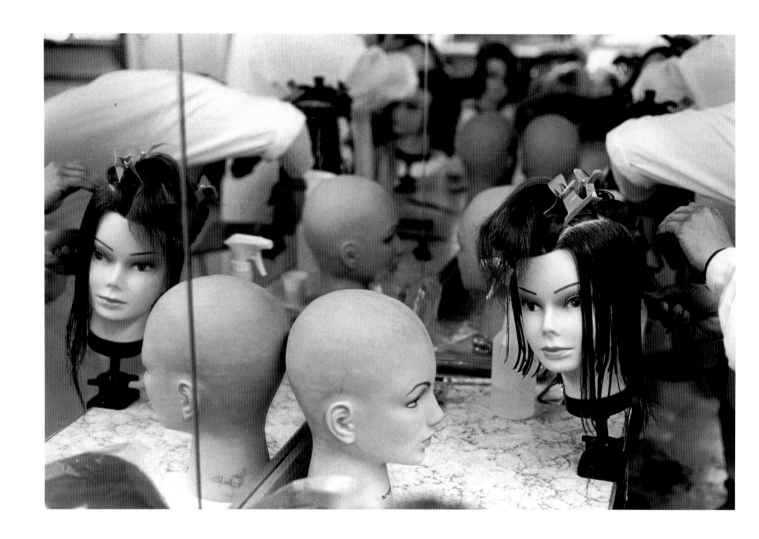

BEAUTY SCHOOLS have served as vehicles of escape for the daughters of poor Maine families for generations, particularly in rural Maine where work options are limited. Over half of Maine's beauticians are self-employed, many working out of their homes. Ninety percent are women.

ABOVE: CENTRAL MAINE BEAUTY SCHOOL. AUGUSTA. 1992. PHOTOGRAPH BY RICHARD SITLER.

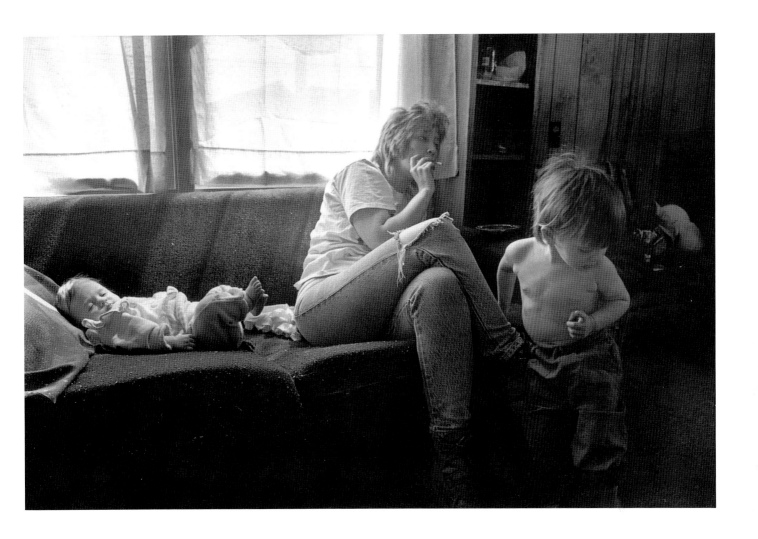

"I'D BUY a beauty shop if I won the Megabucks. I like to have somebody sit down in my chair and just say, 'Go ahead and do whatever you want to do.' Once you learn how to make something happen by putting your fingers a certain way, you can do anything you want." Kelly Randall.

KELLY RANDALL WITH HER DAUGHTERS, NICOLE AND BRITTANY. KELLY ATTENDS CENTRAL MAINE BEAUTY SCHOOL. WINTHROP. 1992.
PHOTOGRAPH BY RICHARD SITLER.
OVERLEAF: MARIAN VEAR, PIPE FITTER, SURROUNDED BY MALE CO-WORKERS. BATH IRON WORKS
SHIPYARD, BATH. 1992. PHOTOGRAPH BY NOREEN HOGAN.

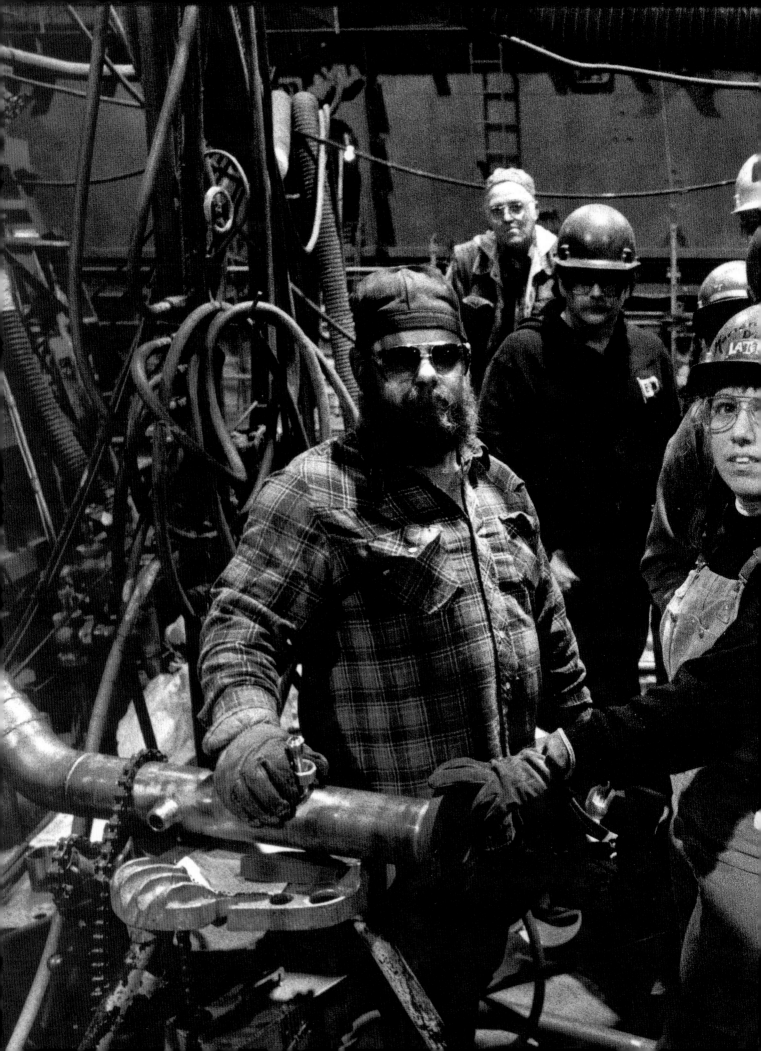

As LONG as there have been woods for the unknowing to get lost in and rapids to capsize over, Maine has had hunting and fishing guides, some of them legendary for their skills and storytelling. Guiding is different today as logging roads bite into the North Woods.

DEER KILL OUTSIDE OF HUNTING CAMP ON ROUTE 161. ALLAGASH. 1991.
PHOTOGRAPH BY LISA ROLLINS.

"YOUR COUSIN was gonna go out and shoot some coots. He'll go out and tie the rig [decoys] off to the lobster boat so they just flop up behind the lobster boat and shoot right off the lobster boat." Pat Keliher, sea duck hunting guide, quoting his uncle, who taught him how to hunt.

STEVE BRETELL, SEA DUCK HUNTING GUIDE, ON ONE OF THE LEDGES OF CASCO BAY. 1993.
PHOTOGRAPH BY PAM BONAGUIDE.

FERRY COMMUTERS talk about a love-hate relationship they have with a boat named the Island Romance. *She takes them from their island homes to Portland, setting their notions of time, steady as the tides. "It's a hassle to be on that boat every day and yet I love it."*

THE ISLAND ROMANCE HEADS OUT OF PORTLAND AT 5:45 A.M., PILOTED BY JOHN TRACY. APRIL 6, 1994. PHOTOGRAPH BY ROLAND LAIGO.

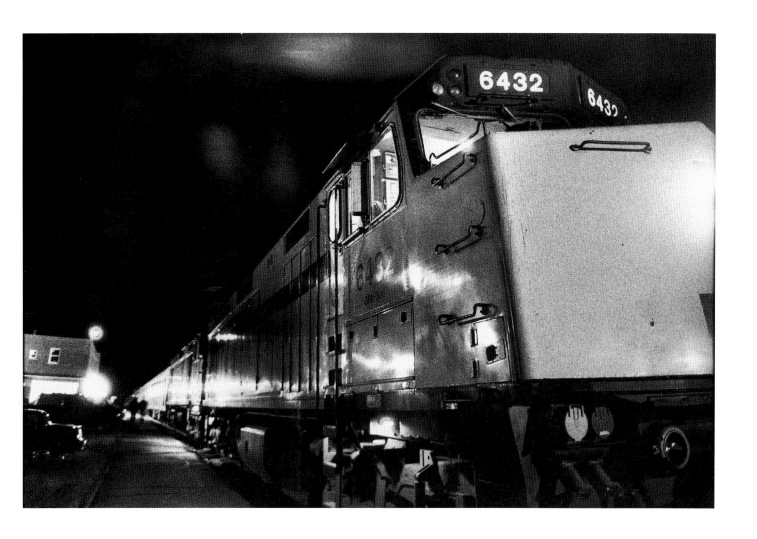

"*I'VE HAD a good railroad life. I've been very fortunate. No accidents. It's rough work, so you can get hurt. You can get killed there. Forty-four years and only one hernia. That's not bad!*" *Bob Roberts, who has worked on the railroad since 1950 and who was born in a town on the line.*

CANADIAN PACIFIC/VIA RAIL PASSENGER TRAIN AT MIDNIGHT STOP IN MAINE. BROWNVILLE JUNCTION. OCTOBER 20, 1993.
PHOTOGRAPH BY CLINT KARLSEN.

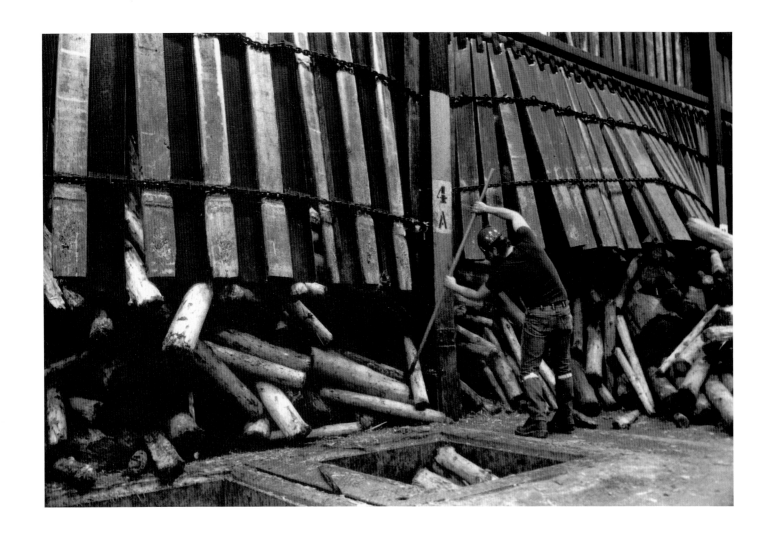

*A*T *A* TIME *when Maine's pulp and paper industry is in decline, both in production and numbers of workers, the Champion mill reached record production levels in 1993. Champion's success lies in niche manufacturing, the making of ultralight paper.*

MAGAZINE LOADER. CHAMPION INTERNATIONAL PAPER CORPORATION. BUCKSPORT. 1993.
PHOTOGRAPH BY MATTHEW ZONTINE.

*"T*HEY'RE *shutting machines down just because of the competition. You've got some of the oldest paper machines, you're talking about early 1900s some of these paper machines." Jim Qualey, worker at Great Northern's Millinocket paper mill in 1991, now owned by Bowater.*

ABOVE: TEARING EXCESS PAPER FROM A NEWLY FORMED ROLL. CHAMPION
INTERNATIONAL PAPER CORPORATION. BUCKSPORT. 1993. PHOTOGRAPH BY MATTHEW ZONTINE.
OVERLEAF: CHAMPION INTERNATIONAL PAPER CORPORATION AT NIGHT. BUCKSPORT. 1993. PHOTOGRAPH BY MATTHEW ZONTINE.

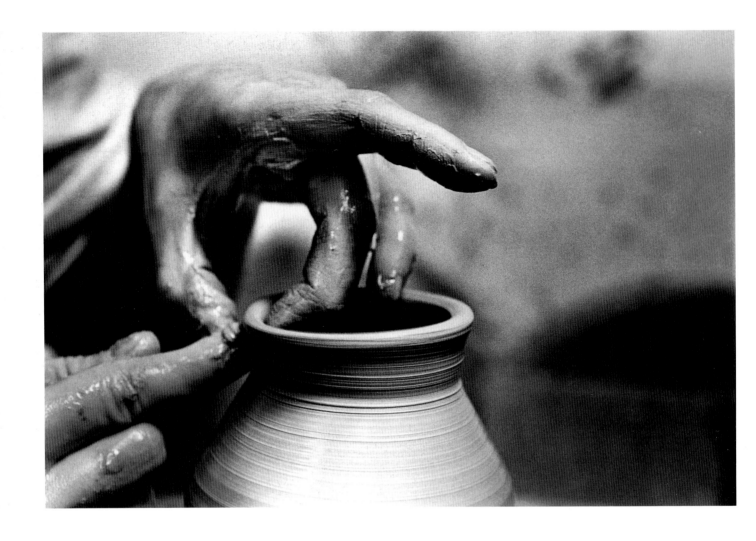

"*ONE OF the real rewarding things about working with clay for me is I do have control over the stuff. I can push it, I can pull it, I can bend it and shape it. I think a lot about flowers and plants and waves and water. Those things are abstracted and become part of my pots.*" *Cathy Schroeder.*

CATHY SHROEDER, POTTER, THROWING CLAY IN COOPERATIVE STUDIO. SOUTH PORTLAND. 1993.
PHOTOGRAPH BY ANNE LEIGHTON MASSONI.

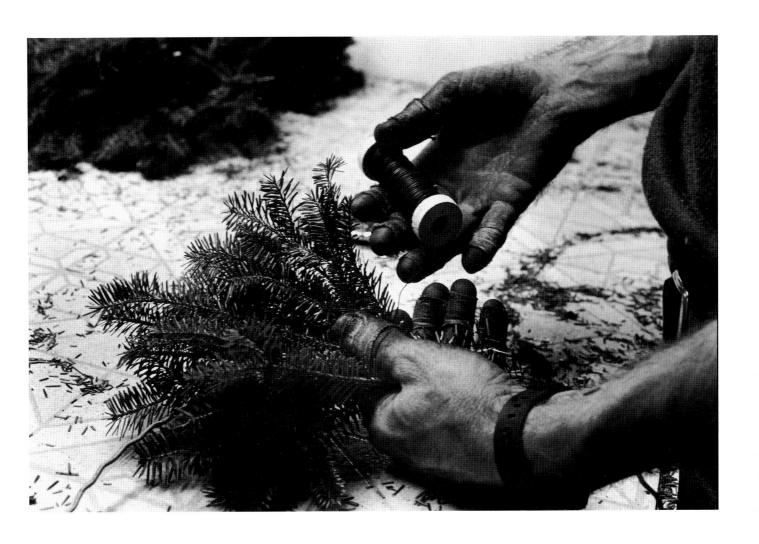

*B*OB *AND LORETTA MacLeod make 2,000 wreaths a year at Tartan Hill Farm—half their income, and the other half is blueberries. It's allowed them to stay on the farm. Two million wreaths were made in Maine in 1990—most from the first of November to mid-December.*

BOB MACLEOD MAKING EVERGREEN WREATH AT HIS HOME/SHOP. COLUMBIA. 1991.
PHOTOGRAPH BY ERIN MILLER.

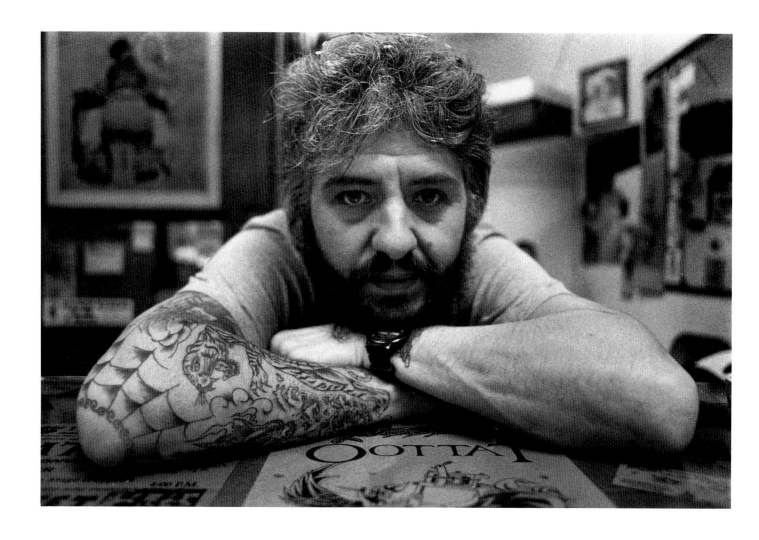

"It's not just a kid or sailor thing anymore,"says Tattoo Ernie Villeneuve of the people who come to him for tattoos. Doctors, lawyers, business people, housewives get the 1,000 tattoos he does each year in Portland. He lures them in with "fine lines and bright colors."

Ernie Villeneuve, "Tattoo Ernie," in his tattoo shop. Portland. 1990.
Photograph by Robyn Redman.

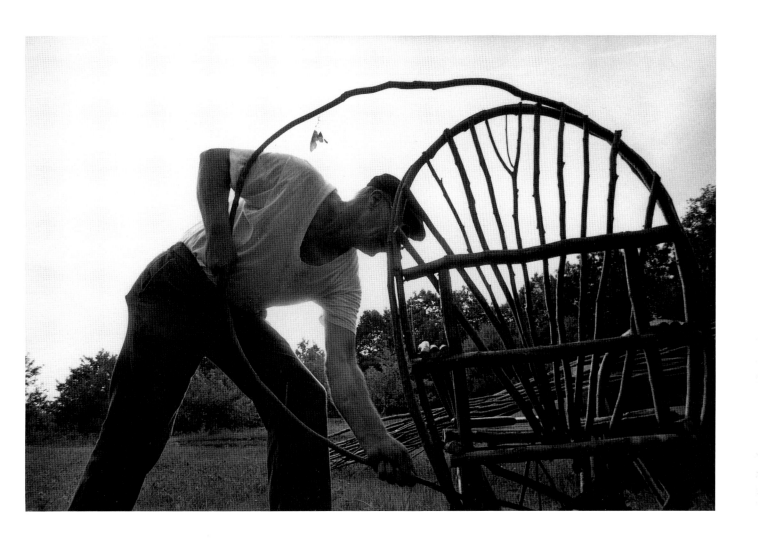

"*WHEN you sit on one of these chairs, you can curl up and escape the anxiety and the world around you. By touching the wood, in a sense you are touching your soul, the soul of the earth. It gives you a contact point to pleasant things.*" *Ralph Bishop, talking about twig furniture.*

RALPH "PORCUPINE" BISHOP AT WORK ON TWIG FURNITURE CHAIR OUTSIDE OF HIS HOME. TROY. 1990.
PHOTOGRAPH BY ERIC LEE.

.

COMMUNITY

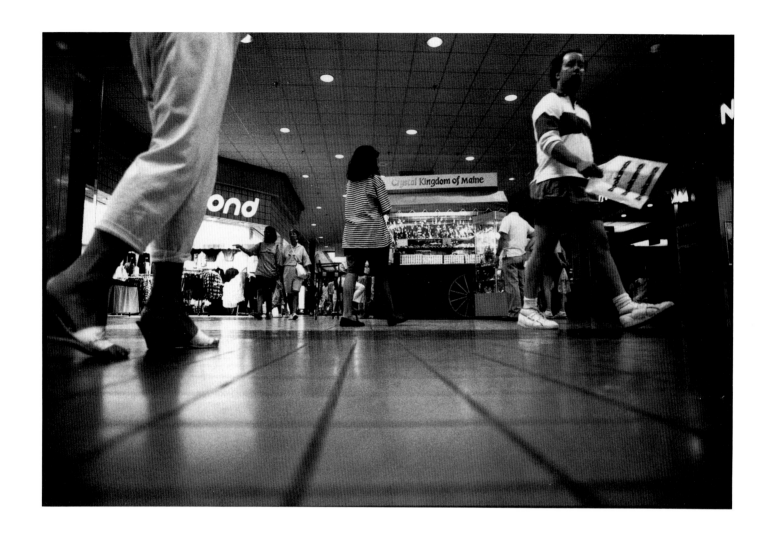

"IT'S HARD being a senior citizen. It's a monotonous life. When you're constructive for a good many years and then you have to relax and do nothing—and you're alone—that's worse. So you come out here to see the living more or less." Harry Lerman at the Maine Mall.

INSIDE THE MAINE MALL. SOUTH PORTLAND. 1988.
PHOTOGRAPH BY JIM DANIELS.

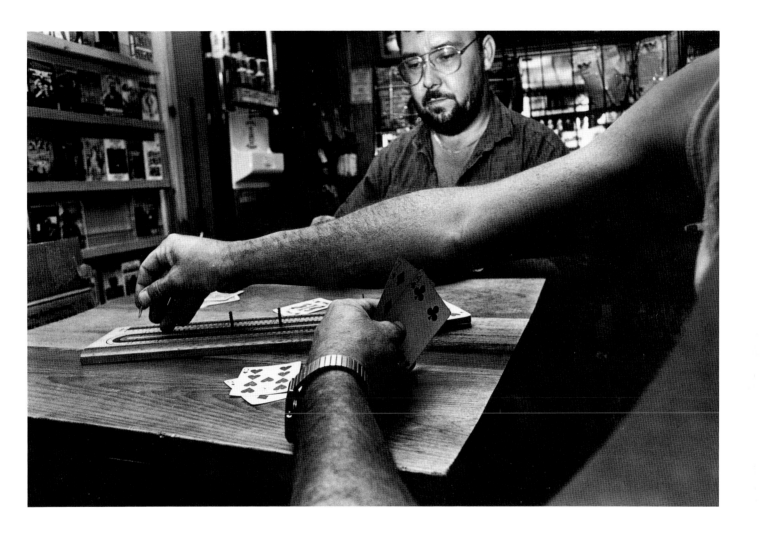

"THERE'S *a lot of professions that no way could make it around here (Benedicta). Everybody's looking for teachers these days. That's why I'm going into that, because I like it around here. I want to come back here. I'll do almost whatever it takes."* Jeannie Robinson, high school senior.

CRIBBAGE GAME IN THE BACK ROOM OF THE BENEDICTA GENERAL STORE. BENEDICTA. 1991.
PHOTOGRAPH BY GARY PRETSFELDER.

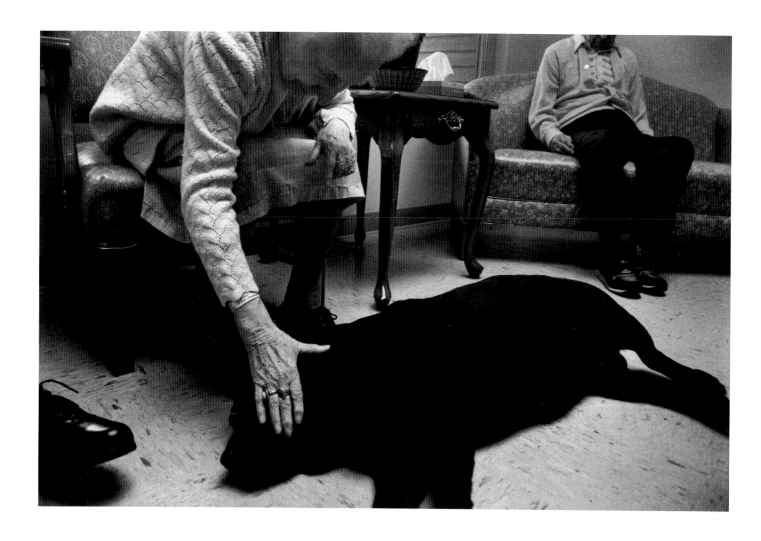

"*I*T'S NOT LIKE *home but it's all that's left to me. They wouldn't let me live there no more. So they dragged me here. The food's not so bad. That's not what's botherin' me.*" Reid Chapman of West Kennebunk when he first went into a nursing home in 1979.*

FRANCES SANBORN PATTING ONE OF THE STAFF'S DOGS. CLOVER MANOR NURSING HOME. AUBURN. 1992.
PHOTOGRAPH BY AYUMI HORIE.

"IT'S THE LITTLE stuff I miss, my stuff. Remember that old cow bell? I wonder where that is, who's got it? There's a kippy little woman that brings me my food. I tease the life out of her. You gotta be around people, all kinds. I miss 'em." Reid Chapman after he entered a nursing home.

BETSY BERG SHOWING PICTURES OF HERSELF WHEN SHE WAS A STUDENT AT HEBRON ACADEMY. SHE'S THE ONE IN THE CENTER KNEELING. CLOVER MANOR NURSING HOME. AUBURN. 1992.
PHOTOGRAPH BY AYUMI HORIE.

FOR NEARLY all of its life, Opportunity Farm, founded in 1910, oper-ated as an orphanage model with strict discipline and privileges awarded by points. In 1991, the farm adopted the "Boys Town Model" with its emphasis on individual responsibility and house parent role models.

STORING HAY IN BARN. OPPORTUNITY FARM FOR BOYS. NEW GLOUCESTER. 1992.
PHOTOGRAPH BY ALLYSON MEHLEY.

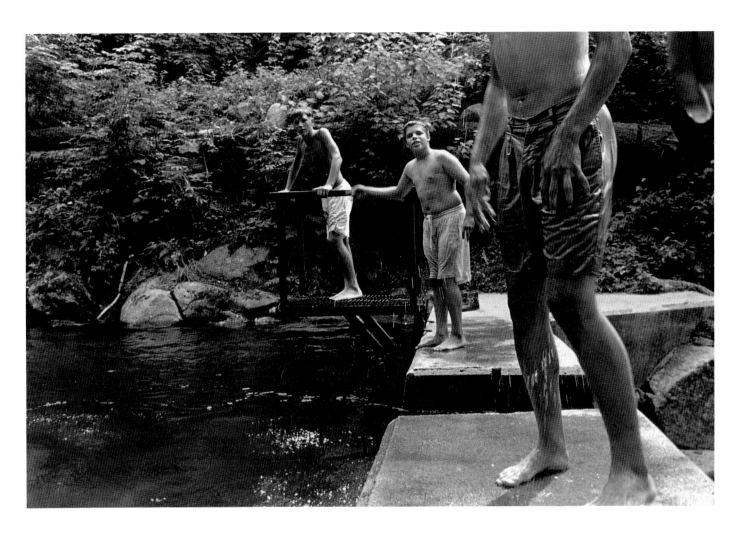

"IT WAS A MESS. This place right now is so much different than when I got here. Because when I came there were 40 guys here. There was up to 17 in each building." Jackson Nadeau, age 18, who came to Opportunity Farm seven years ago. Now there are five to eight boys to a building.

ABOVE: SWIMMING DURING A HIKE IN NEW HAMPSHIRE. YOUTHS FROM THE
OPPORTUNITY FARM FOR BOYS AT NEW GLOUCESTER, MAINE. 1992.
PHOTOGRAPH BY ALLYSON MEHLEY.
OVERLEAF: CITY OF LEWISTON. 1988. PHOTOGRAPH BY CLAIRE SULLIVAN.

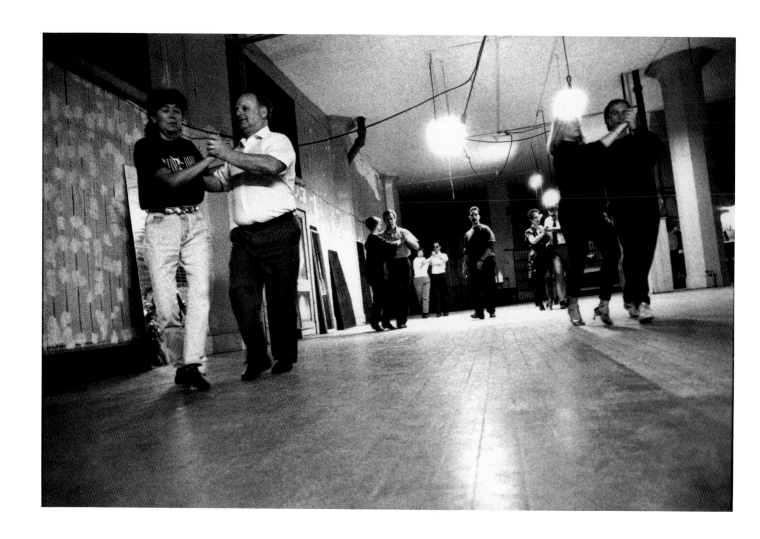

"*I*F *YOU had ever asked me four years ago if I would be sitting here talking about dance shoes, I would have thought you were crazy. It's a confidence builder, something you can do—that you can do well, better than anyone else." Jan Sullivan.*

BALLROOM DANCING AT THE GOTTA DANCE STUDIO. PORTLAND. 1993.
PHOTOGRAPH BY SHANNON BURKERT.

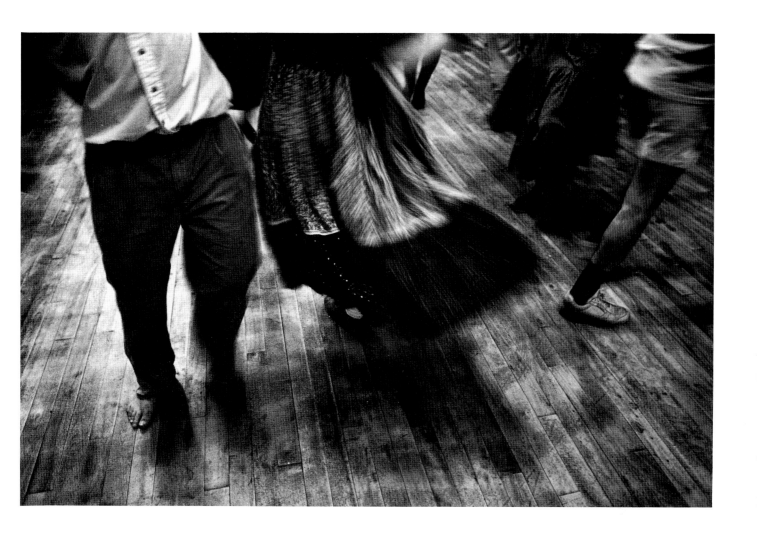

"*THE DANCING in Maine is, in general, rowdier than the dancing that I've experienced in Boston or in Vermont. It feels to me that there's a tremendous amount of interaction between the energy of the dancers and the energy of the musicians, and it grows.*" *Elaine Malkin.*

CONTRADANCING AT BOWDOINHAM GRANGE HALL. BOWDOINHAM. 1992.
PHOTOGRAPH BY CHRISTOPHER DARDARIS.

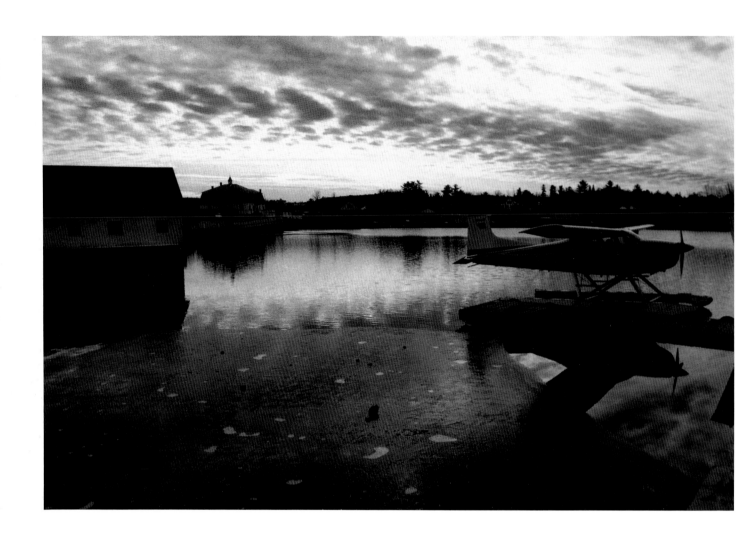

GREENVILLE *has always been the jumping off place for the Great North Woods, a frontier town. But the North Woods have changed, the harvesting is mechanized, roads cut through the forest. If the Woods are no longer wilderness, what does that mean to Greenville?*

TOWN OF GREENVILLE AT THE SOUTHERN TIP OF MOOSEHEAD LAKE. 1991.
PHOTOGRAPH BY KIM MORTON.

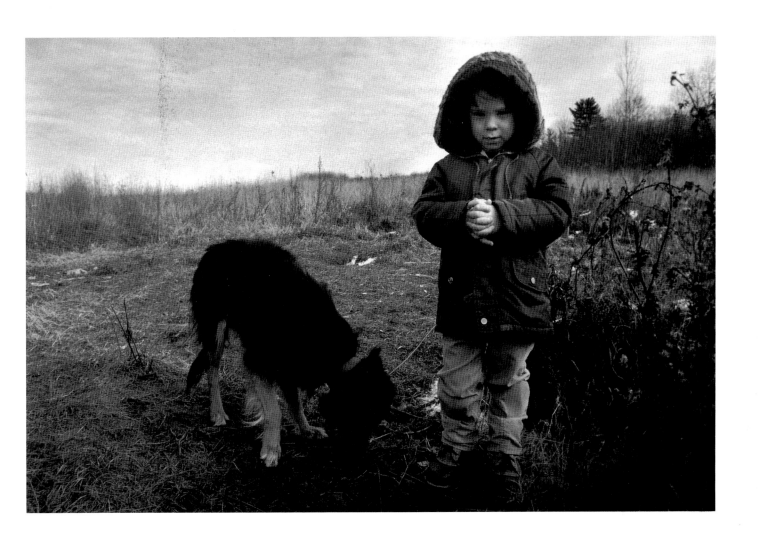

"I'VE ALWAYS told people who come here, 'It's a wonderful place to live, it's a horrible place to make a living.' You've got to know that your lifestyle's going to include getting along on what you get." Ed Walden, great great great grandson of Greenville's founder.

YOUNG BOY WITH DOG ON THE OUTSKIRTS OF GREENVILLE. 1991.
PHOTOGRAPH BY KIM MORTON.

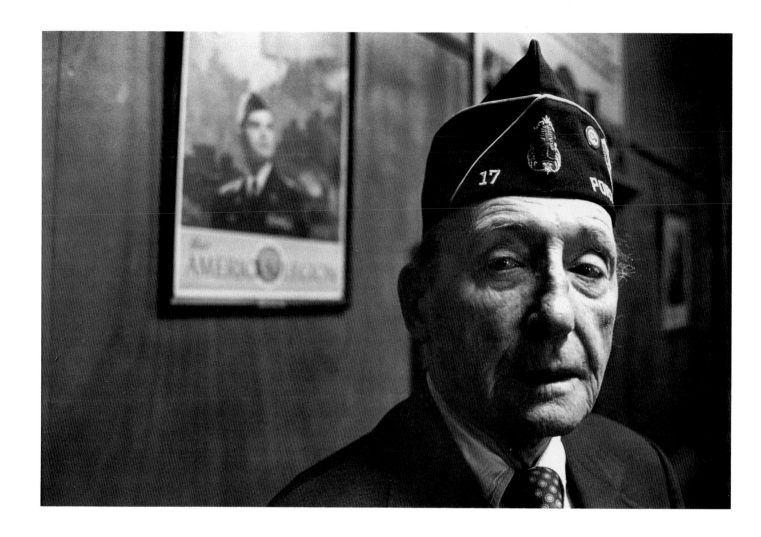

*G*OING INTO *"the service" and often to war is one of few options for milltown boys and Maine farm boys who don't want to stay on the farm. One family in Jackman, all eight sons went. Those that return join veterans groups to continue being with others who know what it's like.*

D*ON* N*ORTON*, P*OST* C*OMMANDER*, *AT* H*AROLD* T. A*NDREWS* A*MERICAN* L*EGION* P*OST* N*UMBER* 17. P*ORTLAND*. 1991.
P*HOTOGRAPH BY* J*OSHUA* G*ALLANT*.

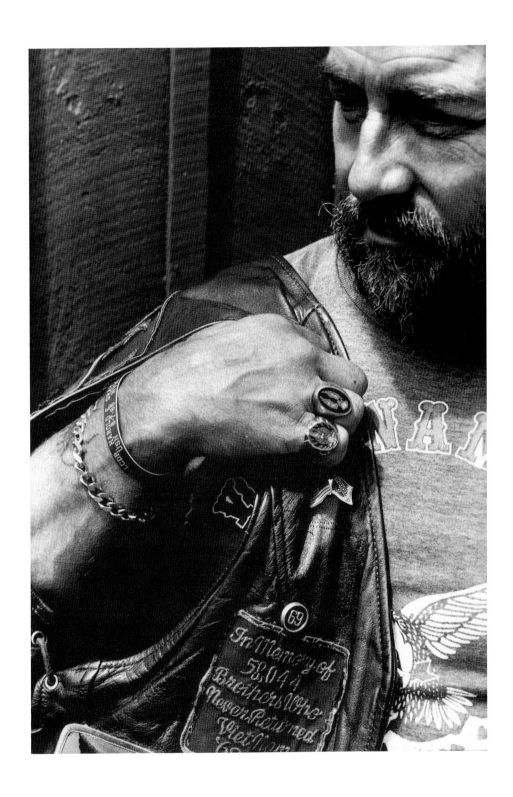

ABOVE: HOWIE YOUNG, VIETNAM WAR VETERAN MOTORCYCLIST, OUTSIDE HIS HOME. KENNEBUNKPORT. 1993.
PHOTOGRAPH BY ERIN HOOPER.
OVERLEAF: TOWN OF STOCKHOLM. 1988. PHOTOGRAPH BY TONEE HARBERT.

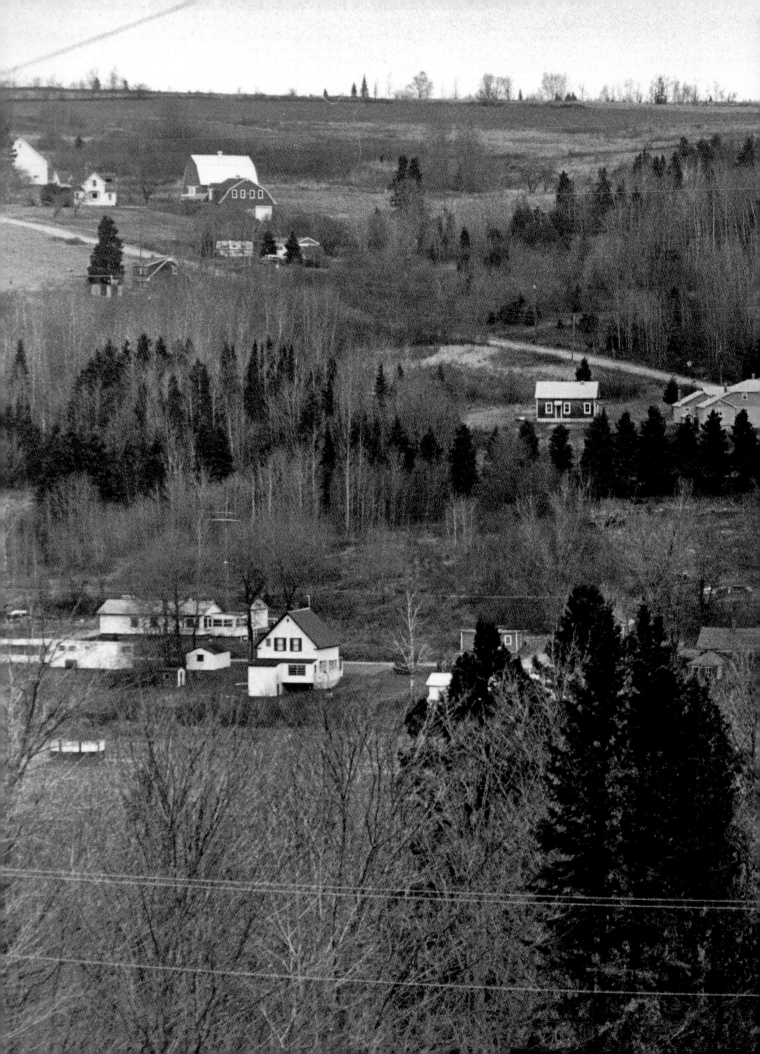

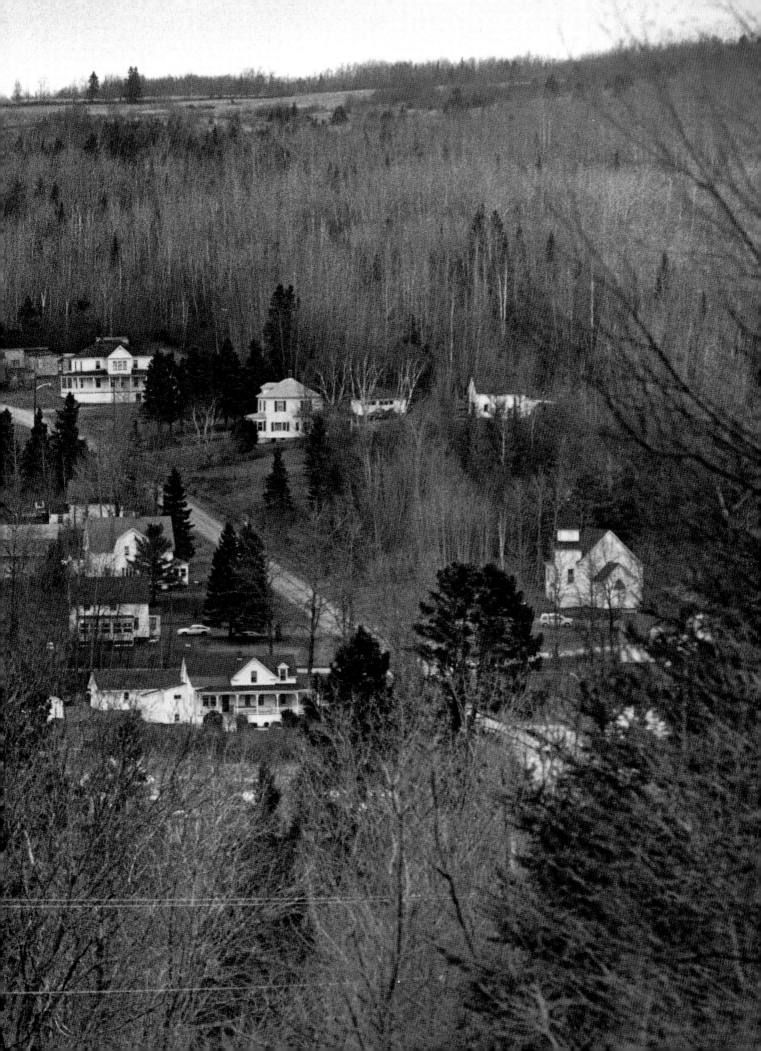

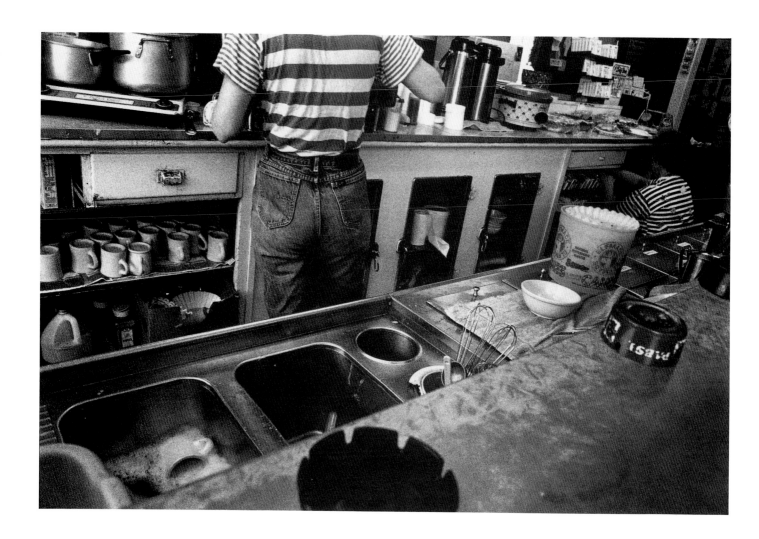

"IT'S A NICE little town. And it is NOT a man's town. Maybe back years ago, it was a man's town. But there are a lot of working women in this town. I don't think it's a man's world anymore. Now women have to work to strive to help keep a household and a family going." Gale Boston.

FRIEDA HUNTER COOKING BEHIND THE BREAKFAST AND LUNCH COUNTER OF FLYNN'S NEWS. SOUTH BERWICK. 1992.
PHOTOGRAPH BY SUSANNAH ROSS.

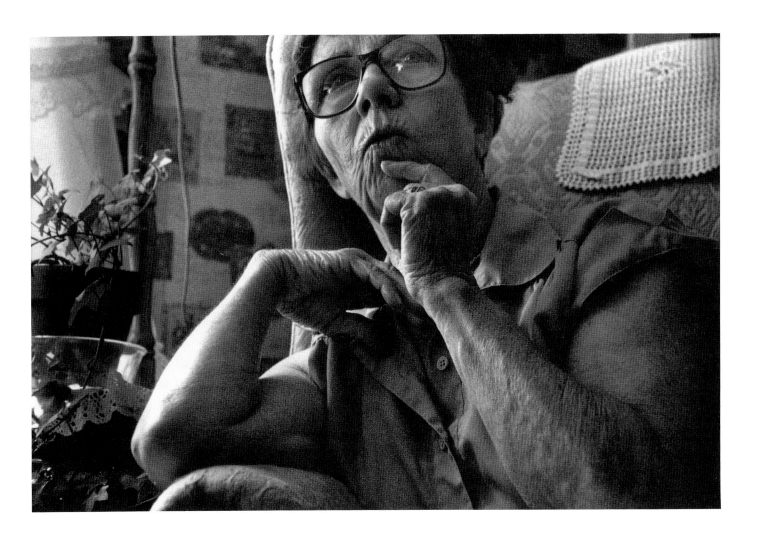

"MY MOTHER *did everything that the men could do. She worked in the fields, drove the horses where women, for the most part in those years, were homemakers. I mean she could use a hammer, a saw.*" Ruth Howarth, talking about the role of women in South Berwick.

RUTH HOWARTH AT HOME IN HER LIVING ROOM. SOUTH BERWICK. 1992.
PHOTOGRAPH BY SUSANNAH ROSS.

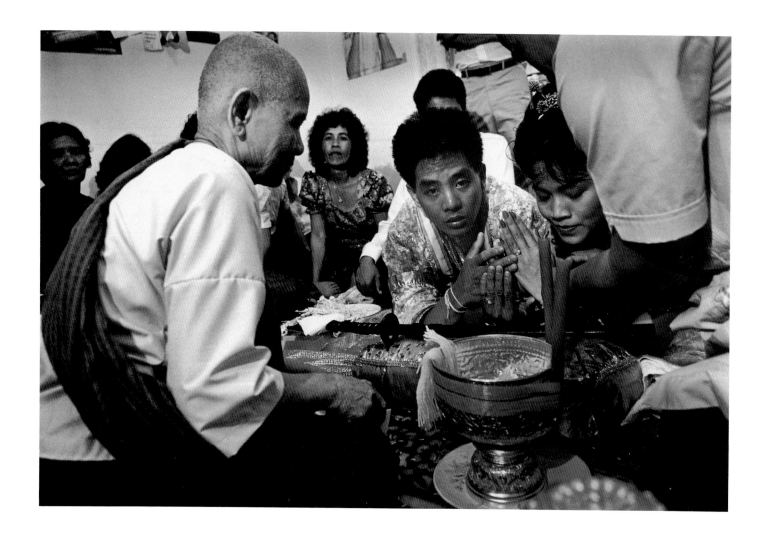

"I THINK HER PARENT believe I take good care of her. That's why they let me married with their daughter." Sophy and Chuon, part of Portland's growing Cambodian community of 600, were married in a traditional ceremony that took over four hours, with nine separate rituals.

TRADITIONAL CAMBODIAN WEDDING OF SOPHY IM, AGE 17, AND
CHUON MUTH, AGE 22. GRANT STREET. PORTLAND. JUNE 20, 1992.
PHOTOGRAPH BY FRANK G. MILLER.

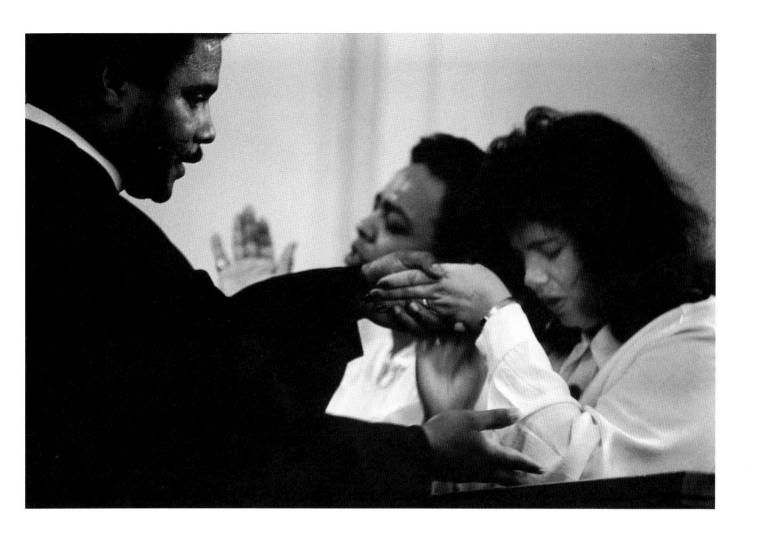

"LIKE A MIGHTY ARMY moves the church of God." Green Memorial

African Methodist Episcopal Zion Church traces its beginnings to 1828 in

Portland. The church was renamed Green Memorial to honor Moses

Green, born a slave, who worked 52 years at Portland's Union Station.

REVEREND CHARLES MATHIS. GREEN MEMORIAL AFRICAN METHODIST EPISCOPAL ZION CHURCH.
MUNJOY HILL. PORTLAND. 1990.
PHOTOGRAPH BY ZENA CALHOUN.

"*THE CITY cheated the people. They destroyed a whole way of life. Some intellectual midget decided that the community would be better served by eliminating it and creating those houses that I wouldn't even let cockroaches live in." Camillo Breggia, on razing Portland's Italian district.*

St. Peter's Parish Catholic Church. The Italian Church. Portland. 1993.
Photograph by Anne Leighton Massoni.

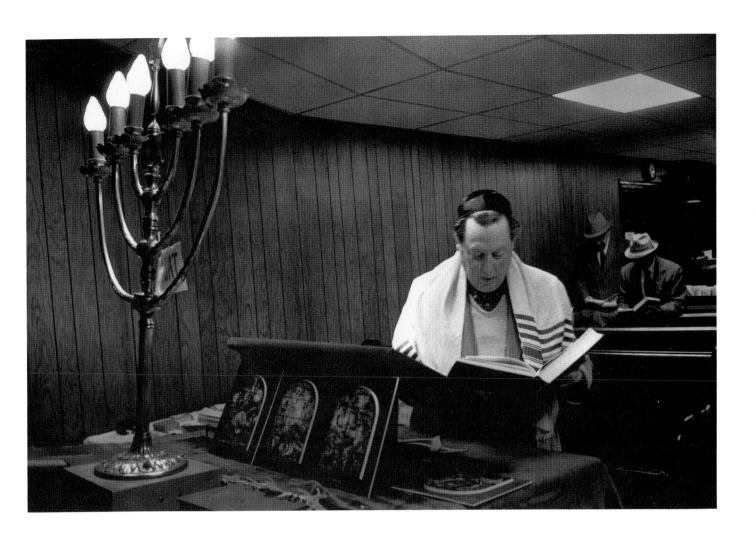

"YOU CAN *walk down the street and pray if you want to. You don't*

even have to be in a synagogue. But, in Jewish tradition, there are . . .

certain prayers which are said at certain times, only when there's a group

together, a group of ten males." This is a minyan, Richard explains.

ABOVE: ETZ CHAIM SYNAGOGUE. CONGRESS STREET. PORTLAND. 1992.
PHOTOGRAPH BY R. TODD HOFFMAN.
OVERLEAF: JOHNNY SODERGREN WITH GRANDDAUGHTER, LENA, PREPARING KORV, A TRADITIONAL
SWEDISH SAUSAGE, FOR CHRISTMAS. STOCKHOLM. 1988. PHOTOGRAPH BY TONEE HARBERT.

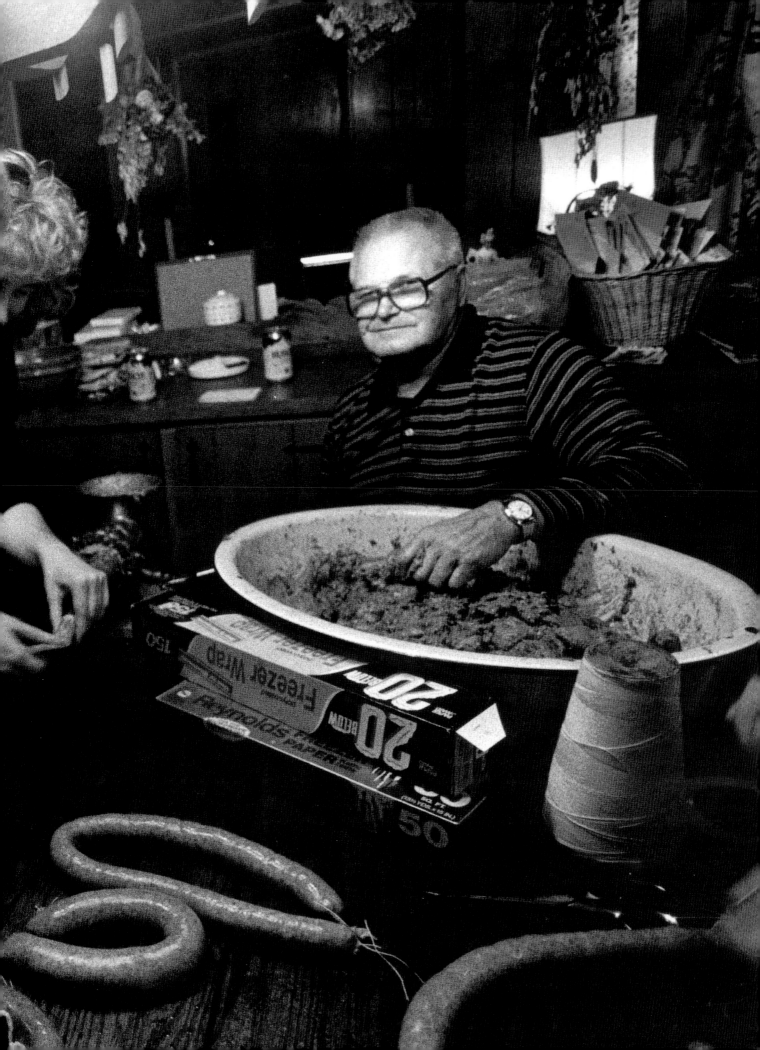

"I ALWAYS loved this neighborhood. I wouldn't be happy anywhere else. I've got a lot of people around. We go out and sit on a bench and we can talk to any of our neighbors any time of night. I know everybody within four or five blocks of here." Eddie Murphy, about the West End.

EDDIE MURPHY, CENTER, HIS BROTHER, FRANK MURPHY, LEFT, AND NEPHEW, JAMES MURPHY, RIGHT,
IN THE TYNG AND TATE STREETS NEIGHBORHOOD. PORTLAND. 1990.
PHOTOGRAPH BY TONEE HARBERT.

MONICA WALSH IS a waitress in Portland's Old Port. What she does to support herself is not what she wants to be (an artist). Some call her crowd the "twenty nothings." Her friends are her family. They share their art, their beer, their after work hours and their last $10.

MONICA WALSH. PORTLAND. 1992.
PHOTOGRAPH BY KATE D. PHILBRICK.

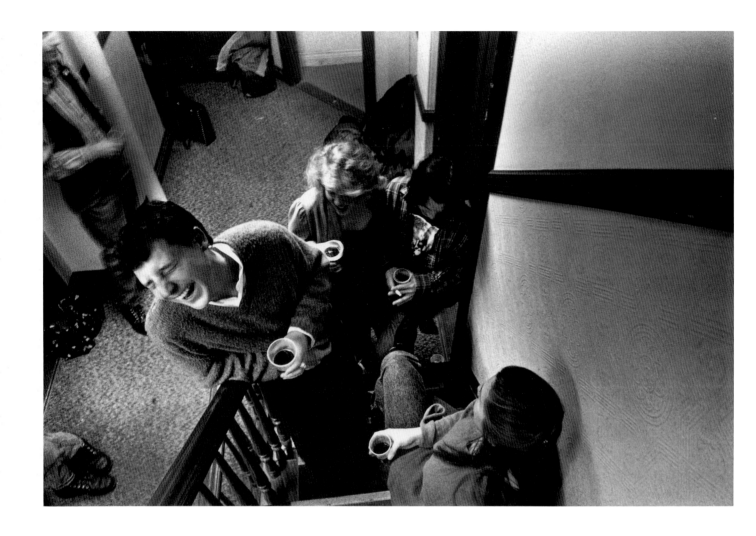

"*I* INTENDED *in majoring in international business and marketing. I thought I wanted to make a lot of money really fast. I wasn't into it at all. I took a drawing class and my professor coaxed me into the Art Department.*" Eric Brown, who worked as a waiter, celebrating his photo show.*

ERIC BROWN, AMY RAY, DR. JONES (NATHANIEL DAVIS), MONICA WALSH AT OPENING OF ERIC AND AMY'S
ART SHOW, "TRIP TO BATH." PORTLAND. 1992.
PHOTOGRAPH BY KATE D. PHILBRICK.

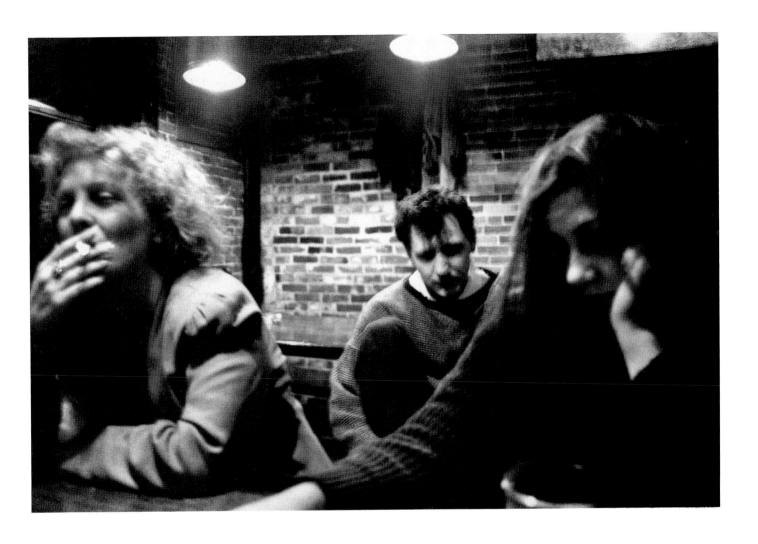

"I FEEL really good about my last body of work. Gives you some sense of control over your life when you're doing stuff that seems important. But in other people's eyes, they think you're not doing any of the things you're supposed to do at this point—I'm thirty-one." Amy Ray.

AMY RAY, ERIC BROWN, MONICA WALSH AT GRITTY MCDUFF'S BREW PUB. FORE STREET. PORTLAND. 1992.
PHOTOGRAPH BY KATE D. PHILBRICK.

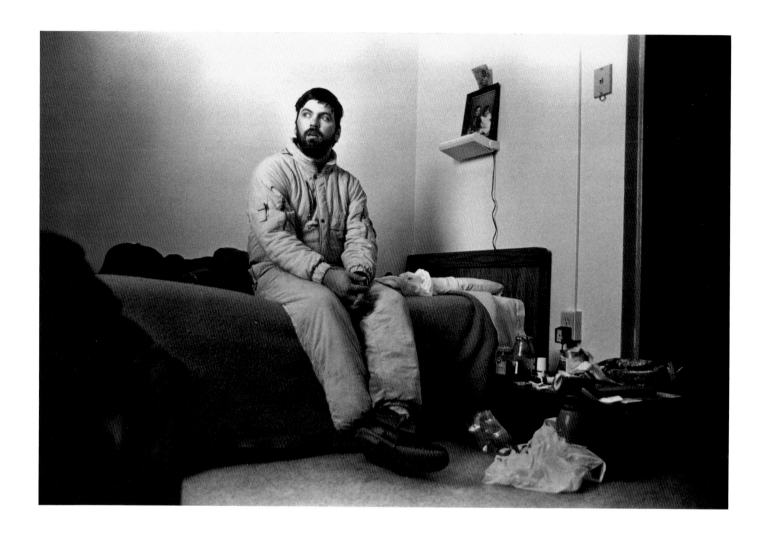

"*I LIKE the Y but I wouldn't want to live here all my life. It's a place to sleep at night . . . and keep myself out of trouble. Somewhere I know I have somewhere to go and if I want to be alone, I can come up here. Somewhere I can be safe.*" *Barry Bernard, age 26, who had been at the Y seven weeks.*

BARRY BERNARD, AGE 26, AT THE YMCA, WHICH HAS BEEN HIS HOME FOR THE PAST SEVEN WEEKS. PORTLAND. 1993.
PHOTOGRAPH BY BERT CASS.

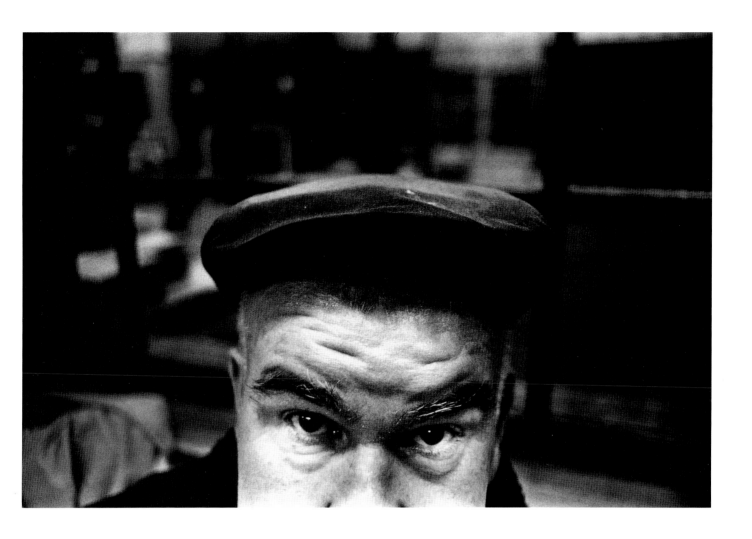

"*THE RESIDENCE HAS been called a nuthouse, a dump, a family, a zoo, a place to hang a hat and a home.*" *Desk clerk of the Portland YMCA, the second oldest in the country, begun in 1853. On the top three floors are 85 single rooms for men. In 1992, the average stay was 33 days.*

ABOVE: JOHN WEDGE, AGE 59. THE YMCA'S LONGEST STANDING RESIDENT OF 20 YEARS.
PORTLAND. 1993. PHOTOGRAPH BY BERT CASS.
OVERLEAF: DARIO MAYORQUIN, AGE 29, RESIDENT AT THE YMCA FOR TWO MONTHS.
PORTLAND. 1993. PHOTOGRAPH BY BERT CASS.

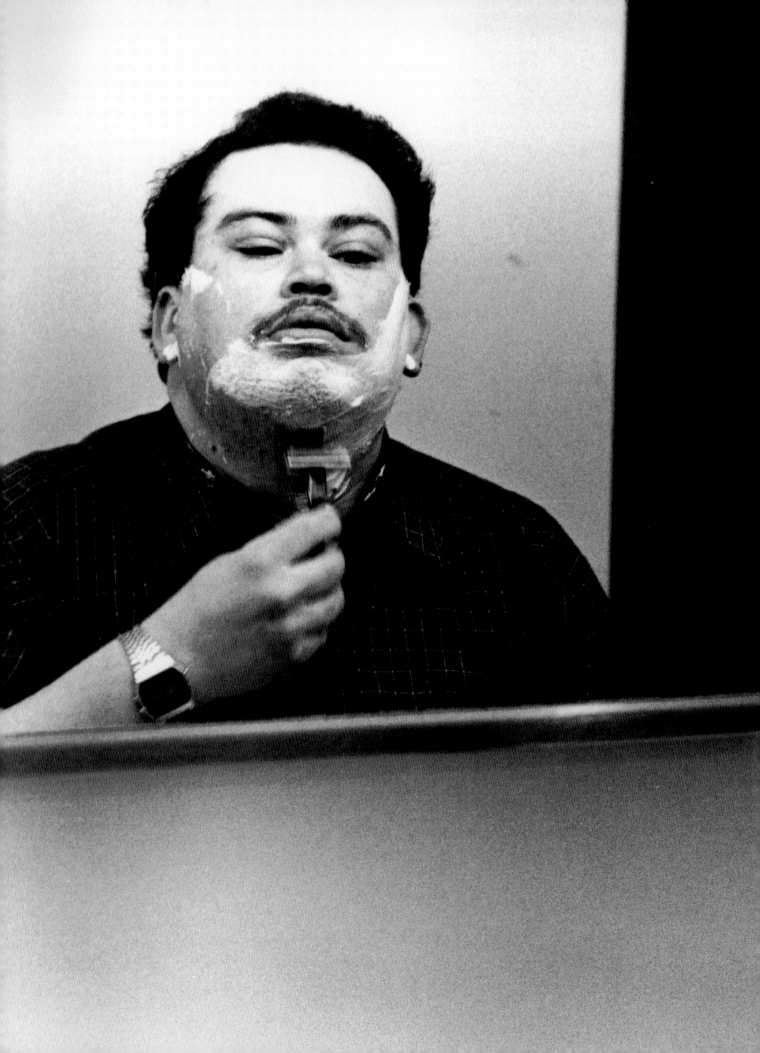

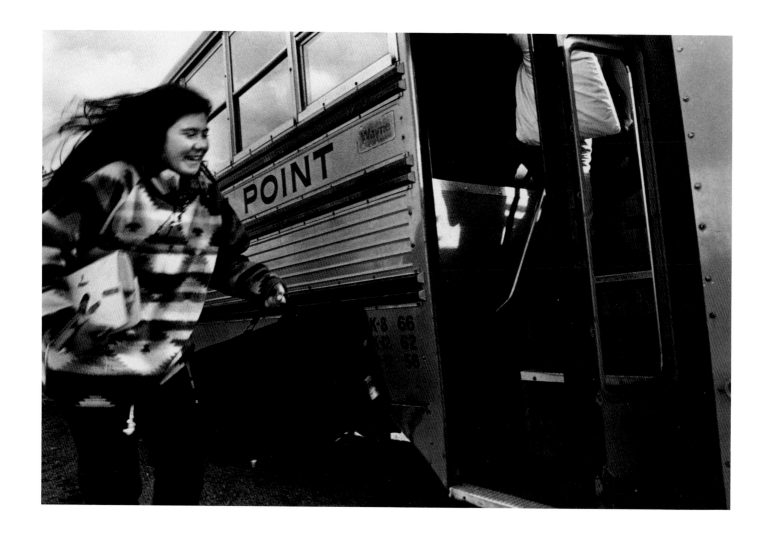

PLANSOWES GOES home to the Passamaquoddy reservation every weekend. She is keeper of the drum at Lee Academy, where 35 Native American students board. At age 15, Plansowes says, "I just know who I am and I know what I am and what they say about me doesn't bother me."

PLANSOWES CATCHING THE BUS TO PLEASANT POINT RESERVATION FROM LEE ACADEMY. LINCOLN. 1993.
PHOTOGRAPH BY JULIE JORDAN.

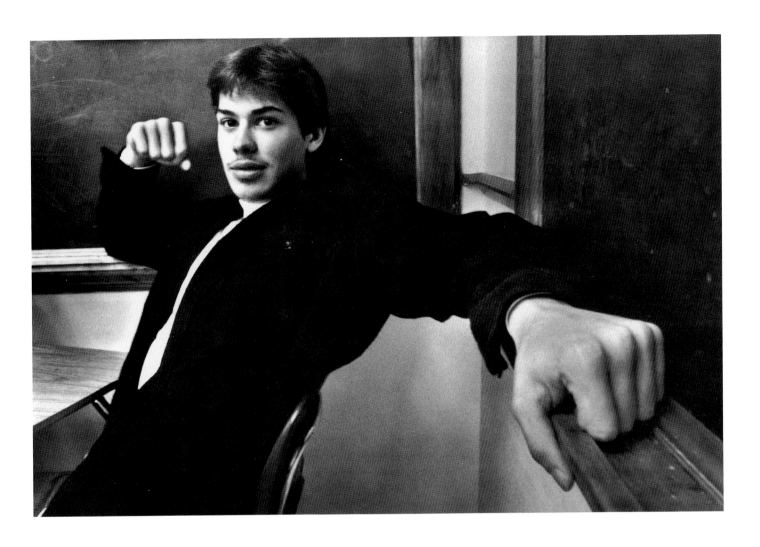

"*I WALK THROUGH the hall and occasionally some guy comes up and says, 'I feel like an asshole for being white, man.' And all I say is, 'Well, you are.' You know what I mean? Just because he thinks he is, I mean he is."* Chris's father is Passamaquoddy, his mother French.

CHRISTOPHER ALTVATER IN KEVIN RITCHIE'S NATIVE AMERICAN LITERATURE CLASS, LEE ACADEMY. LINCOLN. 1993.
PHOTOGRAPH BY JULIE JORDAN.

WINNIE MACDONALD, TWO AND A HALF YEARS BEFORE SHE DIED OF AIDS AT AGE 42. PORTLAND. 1991.
PHOTOGRAPH BY JEFF JORDAN.

"THE BIGGEST misconception is that I'm only half as capable, that I can't do as much. This is part my fault because I've not taken as much initiative. I need to start proving I am a more competent individual, I can do these things." John Lee, talking about being blind in the workplace.

JOHN LEE, AGE 25, WHO HAS BEEN BLIND SINCE HE WAS TWO. HE WORKS AT UNUM IN PORTLAND. 1994.
PHOTOGRAPH BY MARSHALL CLARKE.

"*You tell anyone down home you're going camping and what comes into their minds? It's that you're out there in a tent in the Maine wilderness.*" *Bob Corthell, who camps at Lakeside Pines, which is virtually a town. The campground can hold 800 people.*

Tourism of camper-trailers. 1986.
Photograph by Ken Kobre.

"THEY COME EVERY year for a vacation. They stay for a week at the motel here and they eat lobsters noon and night every day of the week. 'Cause they can't get good seafood in Pennsylvania and they know it."
Bob Young, about his customers at Young's Lobster Pound, Belfast.

ABOVE: TOURISTS AT MOTEL IN SOUTHERN MAINE. 1986.
PHOTOGRAPH BY KEN KOBRE.
OVERLEAF: JAY WARREN, DRUM MAJOR. BOOTHBAY HARBOR ALUMNI COMMUNITY BAND. BOOTHBAY HARBOR. 1993.
PHOTOGRAPH BY DAVID FLEISCHNER.

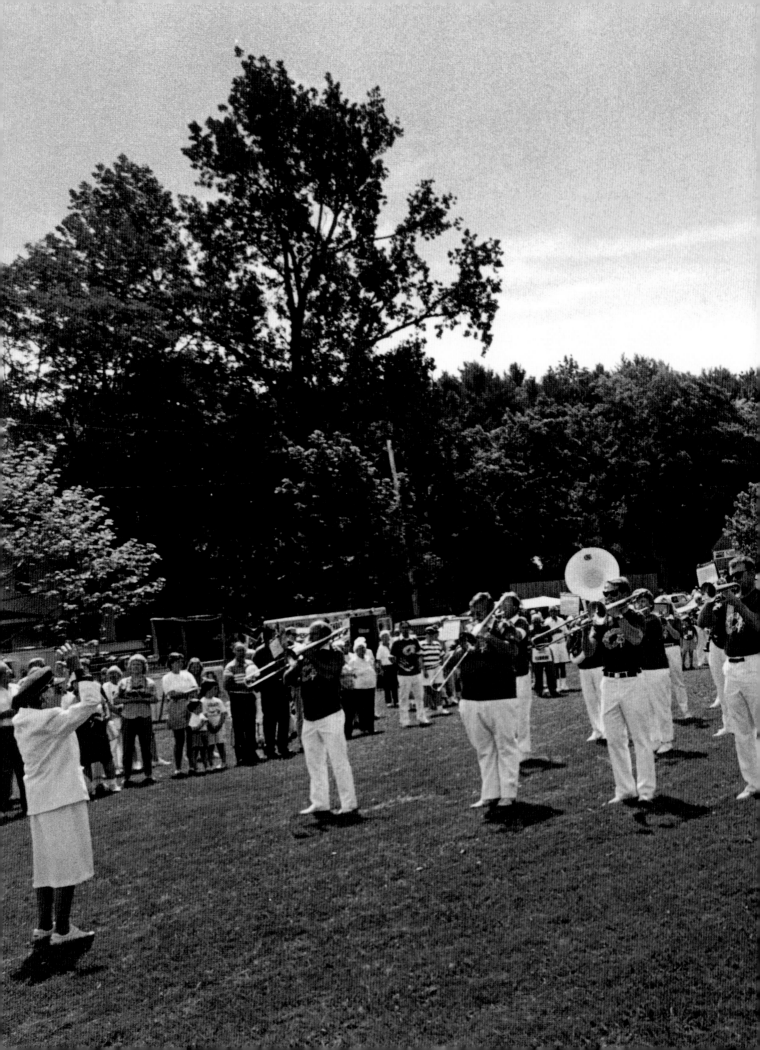

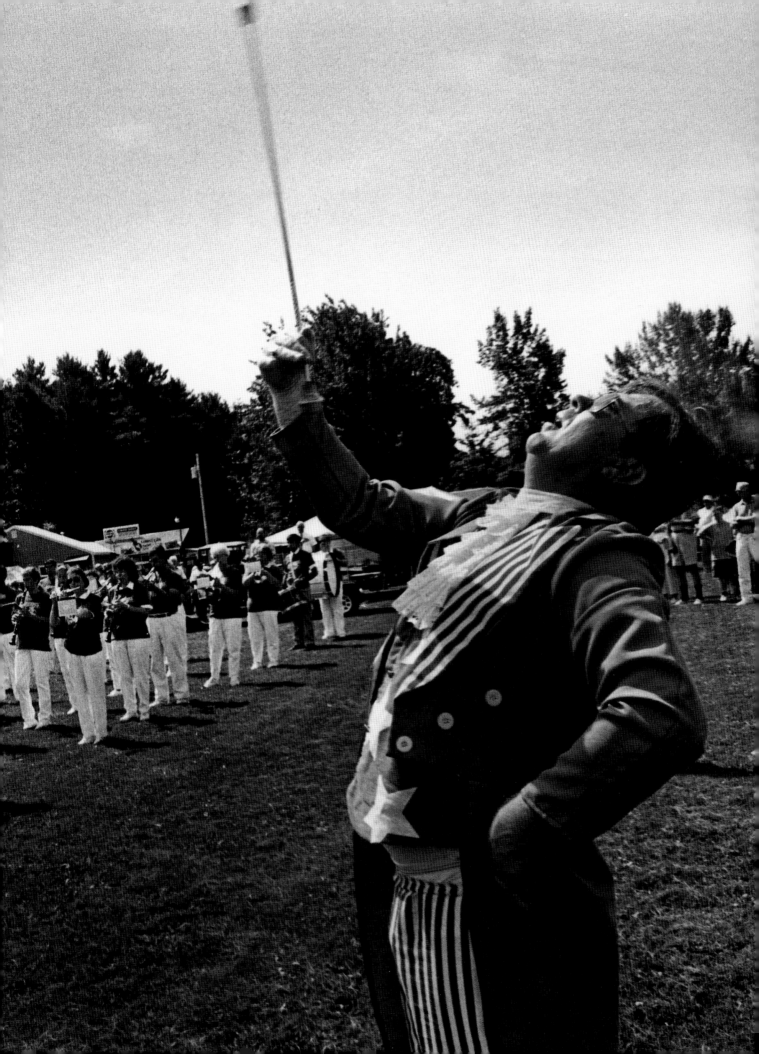

ESSAYS

THE DOCUMENTARY
PHOTOGRAPH IN MAINE'S PAST

C. Stewart Doty

THE SALT Center for Documentary Field Studies stands on the shoulders of a long documentary photography tradition in Maine. Finding that tradition is not easy, however. The problem is twofold. For one thing, the tradition meant different things at different times. What photographers thought worthy of documenting in the past was not always what we wish that they had recorded. For another thing, we know that "documentary photographers" take "documentary photographs," but we are not always certain how to categorize those wonderful images captured by amateur or publicity photographers. Moreover, the historic photographs of the documentary tradition, however defined, are difficult to find. This essay seeks to define for today's Maine people the documentary tradition of Maine. It also examines representative photographs and photographers of that tradition. Finally, it seeks to place the Salt Center within that tradition.

Most historic photographs of Maine rest in the state's libraries and historical societies.[1] Many of them appear in town and county histories and in Maine "picture books." In looking at those historic photographs one's first impression is that they reveal two documentary traditions. One tradition consists of the countless images of fires, floods, railroad disasters, group photographs of veterans and organization members. Photographers photographed what was "important," namely, the extraordinary event. They were less likely to photograph the ordinary events of people at work or play. Or, if they did photograph those events, they did not retain the images as being important enough. We should not be surprised by that. Most of us have family photographs of exactly that kind. We photograph our own "extraordinary" events: birthday parties, the opening of Christmas presents, family members in caps and gowns at graduation, photographic documents of vacations at the beach or mountains. We are far less likely to photograph family "ordinary events" like cooking, dishwashing, making beds, or watching television. Few of us have ever been photographed in our workplace, engaged in what we do there. If we, in our family photographs, do not document such activities, how can we be surprised that our forebears behaved the same way? That is, often neither we nor they took pictures the future will be much interested in.

A closer look at the photograph collections and the Maine "picture books" reveals a second documentary tradition, picturesque Maine. This tradition consists of photographs of Maine lobster boats (preferably in a bit of fog) tied up to piers piled high with lobster traps, lighthouses weathering the waves breaking on the rocks below them, breakers crashing on the rockbound coast where there are no lighthouses, fluffy clouds and mountains reflected in lakes, and a tree in fall. This tradition portrays a Maine without people. If people are in these photographs they are there to provide perspective—a canoeist or hunter in that lake,

a lobster fisher in slicker and boots, a viewer surveying the photographed scene. There is nothing wrong with photographs of this variety. Many are beautiful and truly artistic. People like to look at them, and they do reveal the natural world of Maine. Yet, they are more of an artistic photographic tradition than they are of a documentary tradition.

A more resolute search, however, reveals a different documentary tradition, one more congenial to our times and one that prefigures the work of the Salt Center. This tradition portrays ordinary Maine people performing ordinary, indeed commonplace activities. It portrays them at work, at home, in recreation, with families, and at ethnic celebrations. This is the documentary tradition that seems most important to us today. This is the documentary tradition this essay examines.

Given the fact that there are many photographs of floods, fires, lighthouses, and lobster boats, one can but wonder why photographers chose to photograph ordinary people doing ordinary things. When one discovers some unforgettable image of daily life from a day long gone by, one can but wonder why that photographer chose to capture that moment of ordinary life forever.

The photographers of those scenes were of different types. One type, the type that produced the largest number of documentary photographs in the late nineteenth and early twentieth century, was the local professional photographer. Nearly every American town had one or more. These photographers lived by their cameras. In selling their wares, they created the documentary tradition in Maine and America. Their stock in trade was the posed studio portrait. When customers would not come to the studio, they went to the customers. They would visit where people worked, take pictures, and come back with prints for sale. They also were the creators of picture postcards. Of course, every one of their clients posed. That was the idea. Yet, these photographers really were on the spot when others were not. These studio photographers captured a real sense of their regions. Working in their own neighborhoods, they acted as "interested insiders" in documenting the ordinary life of their time and place.

A typical example of professional studio photographer as documentary photographer was E. Joseph Leighton (1884–1957) of Wiscasset, Maine. Leighton's photographs, collected by the Lincoln County Museum, are particularly strong in documenting early twentieth century, mid-coast life. They depict lumbermen sawing logs into boards in portable sawmills, farmers getting milk to the dairy, farm men and women picking apples, and rural folk accomplishing other activities of their lives (Figure 1). Leighton simply walked about the neighborhood with his camera equipment on his back. A Lincoln County diary entry from 1916 notes, "Been gathering apples. Heavy freeze last night. Potted over the plants. Joseph Leighton was here and took a view of the river and Sheepscot from near the buildings."

"He'd walk everywhere," a client of Leighton later recalled, "he'd lug his stuff right on his back. . . . He'd go around and take these pictures, he'd make up and probably sell fifty or sixty of them . . . come back to the mills and sell there, where he could, and he'd go somewhere else. . . . Everybody liked him . . . got to have their pictures taken."[2]

Leighton's life and work in the early part of this century doubtless resembled that of Isaac Simpson, who photographed ordinary life from Bangor to Houlton around 1895 to 1910.[3]

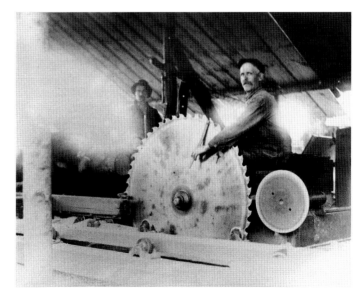

Fig. 1

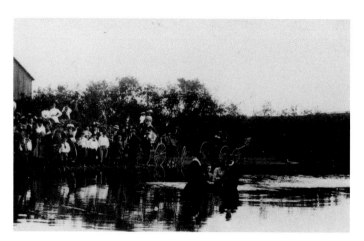

Fig. 2

Simpson's photographs captured such subjects as carpenters engaged in house construction, Christians participating in a river baptism, rural people picking apples, peddlers going about with their wares in wagons, potato harvesters working with hand tools, a road building crew working in a gravel pit, and the immigrant laborers building Millinocket and its paper mills (Figure 2). Simpson made particularly strong photographs of woods work. He recorded the felling of trees, transporting them to the lakeside and riverside landings, and the dangerous log drives down swollen rivers. He also documented the men and women in the interiors of dormitories, kitchens, smithies, dining rooms, and camp stores.

In 1907, another studio photographer, C. F. Clement of Milo, showed the construction of the Medford Cutoff, a Bangor and Aroostook Railroad track running from Lagrange to Packards via Medford. He was hired to immortalize the efforts of George Cuozzo, the *padrone* who assembled the crew of Italian-Americans to do the work. The resulting photographs may be one of the finest, detailed visual records anywhere of horsedrawn road building. Clement's photographs document small groups of Italian-American workers, posed to be sure, engaged in every activity of the work of blazing a railroad through the dense Maine woods, blasting through ledges and removing the debris, and bridging the Piscataquis River on concrete piers (Figure 3). Clement's most widely circulated photographs, ones that he printed and sold as postcards, were

of the first parade of the Ku Klux Klan in New England. The pictures show nearly 200 hooded Klansmen marching in the centennial celebration parade at Milo on September 3, 1923.[4]

In the fashion of Leighton and Simpson, Fred Philpot photographed around Sanford and Springdale from 1880 to 1920.[5] He had studios in those two towns, and the 1,500 glass plates and many photographic prints of his work there are retained by the Sanford Historical Committee. Typical of his work was a fine photograph of men and boys, all wearing hats, hanging about the interior of A. J. Brackett's general store in the Emery Mills of 1895 (Figure 4). The walls are lined with canned goods. On the counter is a hand coffee grinder. Another photograph captured the whitebearded James Larrabee standing in the doorway of his harness shop in Alfred of the 1880s.

Photographs similar to those of Leighton, Simpson, Philpot, and Clement have been retained for the town of Thomaston. Vintage prints by Enoch C. Fernald record workers in a sail loft of 1873, a daydreaming clerk in W. J. Fernald's store of 1870, cell blocks of the Maine State Prison in 1870, several good photographs of quarrying in the 1870s. Emily Creighton Smith took a particularly evocative photograph of a woman resting on a stone wall

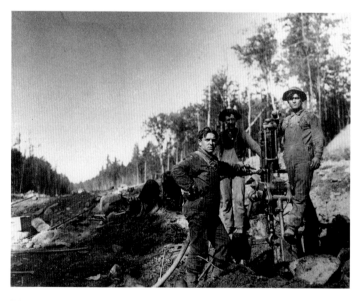

Fig. 3

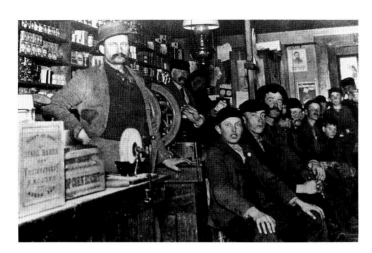

Fig. 4

by a horse and buggy in 1898 and another of two female telephone operators in 1897 (Figure 5).[6]

If photographers like Leighton, Simpson, Clement, Philpot, and the Thomaston photographers were "interested insiders," a second type of documentary photographer was the "interested outsider." They were either visitors from out-of-state or local people whose gender or class put them "outside" the world captured by the male photographers. Indeed, the "interested outsider" was often more likely to photograph what is interesting to us than someone who lived or worked in the place being photographed. To "interested outsiders," every day local events and activities were "ex-

traordinary." To the people and places photographed, of course, they were ordinary.

Typical examples of the "interested outsider" were Chansonetta Stanley Emmons, Emma D. Sewell, and George Hawley Hallowell.[7] Hallowell (1871–1926), a Boston painter, regularly came to Maine to photograph logging scenes. He did it to collect raw material for his paintings. Perhaps the greatest logging photograph anywhere is his image of river drivers breaking up a jam on the Wassataquoik River drive in the first decade of this century (Figure 6).[8]

Photography was such a small world in the late nineteenth century that women photographers like Emmons and Sewell were accepted by the males of the emerging profession. Emma D. Sewell lived in Bath most of her life. Chansonetta Stanley Emmons grew up in Kingfield and regularly summered there as an adult. They were well connected. Sewell's husband, Arthur, was a vice presidential candidate with William Jennings Bryan in 1896. She was forty-eight years old when she got her first camera in 1884. She frequently exhibited her photographs in Boston. When her husband died in 1899, she gave up photography. Emmons, sister of the Stanley brothers, the photography and automobile developers, took to photography as a young widow. As "interested outsiders," they photographed rural

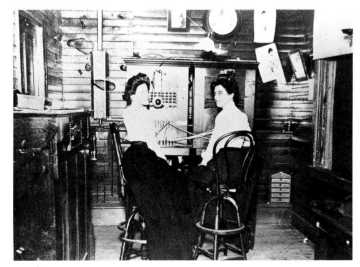

Fig. 5

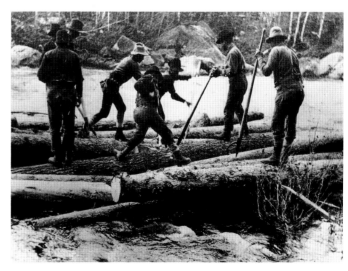

Fig. 6

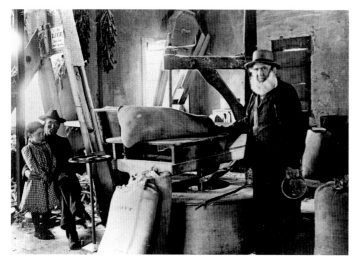

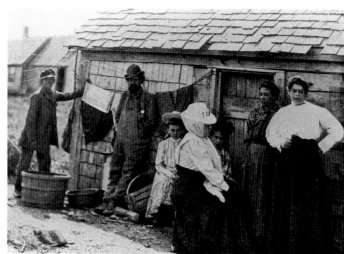

Fig. 7

Fig. 8

Maine life as if they were recalling it from their childhood and from their perspective as women. In her fifteen years as a photographer, Sewell took wonderful pictures of coastal life—a woman quilting, a woman and her daughter sitting at the cottage door peeling potatoes, other women weaving, knitting, or spinning, a fine sequence on haying with ox power, a dory lobsterman pulling traps, another sequence of clamdiggers in boots and with rakes, and an evocative image of Small Point harbor in those days. Emmons' work is especially strong on interior scenes of women homemakers at work and men doing such chores as husking and shelling corn (Figure 7). At the same time these "outsiders" were not outside at all. They were, after all, women familiar with women's work and woman's situations, albeit in a different setting. Surely making an artistic quilt is an "extraordinary" event and not commonplace.

Nor were all the "interested outsiders" interested in idyllic rural settings. In 1909 Holman Day, Maine poet and author of *King Spruce,* traveled from Casco Bay to Muscongus Bay in search of coastal poverty as a contrast to the emerging well-off "resorters. " He and his photographer, Frederick Thompson, found it. It is hard to say whether Day spoke through the eight photographs of Thompson or whether Thompson's documentary photographs take on meaning because of Holman's text. Two

photographs stand out, because they are of the people of Malaga Island in Casco Bay. They portray the descendants of the runaway African-American slaves who lived there. One shows a group of these Maine African-Americans "entertaining" a white missionary (Figure 8). Another portrays "Jack, great-grandson of the pioneer of Malaga." We can see the poverty in the photographs, but Day gives it his own gloss. "Certain amateur sociologists have been wondering and planning what to do with Malaga and the Malagaites," he tells us. His race attitudes, typical of his day, made him skeptical of any good results. "Occasionally farmers on the main hire the women to work in the fields," he wrote. "The men are too lazy."[9]

An "interested outsider" one would expect a lot from was Lewis Hine. In the first decade of this century Hine took some of the strongest photographs of the American documentary tradition. His images of Pennsylvania coal miners and Franco-American textile workers in Manchester, New Hampshire, visually defined for Americans the evils of child labor in early industrialization. One would have expected him to do the same for the Maine tradition when he visited Lewiston textile workers in 1909 and the sardine canners of Eastport and Lubec in 1911. In Eastport, he did photograph a poignant sequence of pictures showing eight-year-old Phoebe Thomas "going to

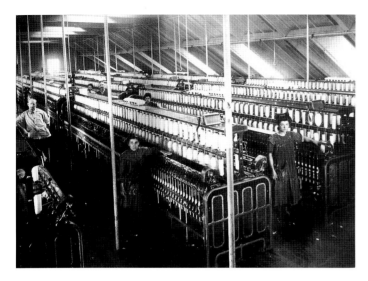

Fig. 9

"interested outsider," seem merely to confirm the preconceived ideas the photographer brought with him.

Oddly enough, stronger visual statements appear in publicity photographs taken to celebrate the accomplishments of the company managers employing the workers photographed by Hine. Two photographs of blank-faced girl spinners and bare-footed boy spinners, taken in Lewiston's Hill mill around 1900, lack only a Hine caption (Figure 9). Looking at them, one wonders whether or not the secret of Hine's work was as much in his captions as in his photographs.[12] A photograph (Figure 10) taken for the William Underwood Canning Company comes even more alive when given the caption of a much weaker Hine photograph of the same period (Figure 11): "Shows how they cut the fish in sardine canneries. Large sharp knives are used, with a cutting and sometimes a chopping motion. The slippery floors and benches, and careless bumping into each other increase the liability of accident. 'The salt gets in the cuts and they ache.' "[13]

work at 6 A.M. . . . with a great butcher knife, to cut sardines." The second picture shows her "running home from the factory all alone, her hand and arm bathed in blood, crying at the top of her voice. She had cut the end of her thumb nearly off, cutting sardines in the factory, and was sent home alone, her mother being busy." The third picture shows Phoebe, all smiles, with her hand bandaged.[10] The Lewiston pictures mostly show mill children, standing outside the mill. The captions merely comment on their age and inability to speak English.[11] The Maine photographs of Hine, the

Indeed, publicity photographs of this quality remain in abundance for the pre-World War I era. A classic work of Maine's documentary tradition was designed as publicity for the Bangor and Aroostook Railroad. Clarence Pullen's *In Fair Aroostook* is a perfect example.

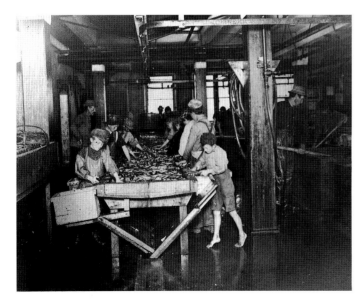
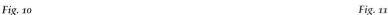

Fig. 10

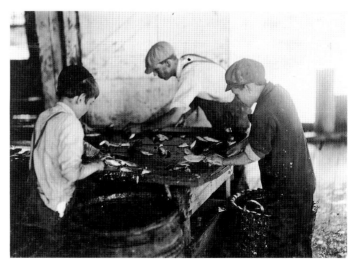

Fig. 11

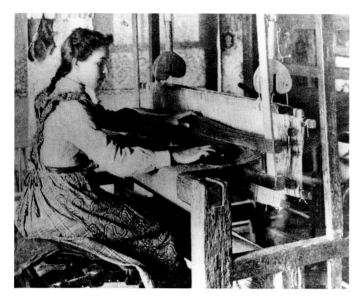

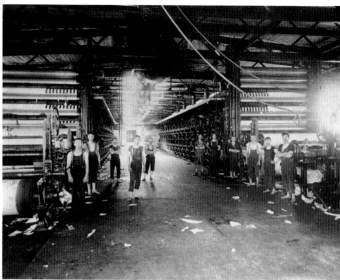

Fig. 12

Fig. 13

The purpose of the book was to encourage out-of-state visitors to come to northern Maine for hunting and fishing. Yet much of it consists of excellent photographs of turn-of-the-century Acadians of the St. John Valley (Figure 12) and Swedish-Americans of Stockholm and New Sweden.[14]

Other publicity photographs from this period are equally interesting. A publicity photograph from the pre-1910 Madison, Maine, mill of the Great Northern Paper Company provides a particular shock (Figure 13). Modern viewers long for a Hine caption. They cannot but wonder how many bare toes were crushed by going barefooted around the heavy paper-making machinery.[15]

Another unexpected source of documentary photographs is the annual reports of the Bureau of Industrial and Labor Statistics for the State of Maine, usually organized around themes. The 1893 report was devoted to summer resorts. It contains many illustrations of summer hotels and a wonderful photograph of a man and woman standing in a canoe and "reeling in the last trout at Rangeley." The 1909 edition has many excellent photographs of potato farming. Perhaps the most stunning one comes from 1894. A photograph of the "Mailing and Subscription Department" of the Gannett and Morse

publishers in Augusta may be one of the first photographs of the new "women's work" (Figure 14). It shows a room full of women sitting shoulder to shoulder, each one in front of a typewriter. The men in the photographs are not at typewriters. They were the supervisors. The photograph was surely designed to show the progressive corporate adaptation to the new technology of the office machine. Viewed today, however, it shows the early labor and gender regimentation of women.[16]

All of these documentary photographs, like most documentary photographs, rarely speak for themselves. Or, they may not say what the

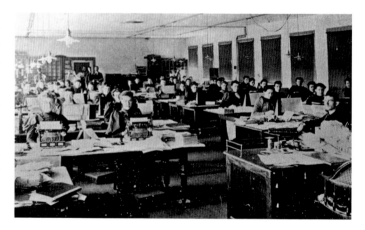

Fig. 14

photographer meant to say. Certainly the photographs of textile, clerical, and paper workers say something different to our generation than they did to the first generation of viewers. Nor can we always figure out what is really happening in the photograph. We can get a sense of the photograph of the women typists, because most of us know how to keyboard. Far fewer of us have been spinners, loggers, or paper workers. Are the young women of Lewiston's Hill Mill tending ring spinners or mule spinners? Is it important to know that? How many machines did each woman tend? What was the noise level? In spite of all the photographs of logging operations, it is still difficult to really grasp how loggers felled trees and transported them over "swamped" roads to the lakeside and riverside "landings," before driving them down river to "booms" where they were sorted and "rafted." The photograph used to illustrate rafting in my book, *First Franco-Americans*, would have made no sense without its caption and Mike Pelletier's oral history. I could not even have identified it as "rafting" without having read Edward D. Ives on the Argyle Boom. That book's diagrams and drawings are more useful than the historic photos. Much the same is true for *The Salt Book*'s chapter on snowshoe making.[17]

Documentary photographs after World War I recapitulate the major themes established before the war: farming, factory work, ethnicity, sporting camps, summer people, the upper classes mixing or not mixing with servants. In the 1920s, Walter G. Hays published a fine panoramic photograph of Old Orchard Beach, jammed with what have to be visitors from Quebec, a rare view of a Rockport lime quarry, and a particularly good image of horsedrawn potato digging in Aroostook County (Figure 15).[18] An excellent recent photographic history of Bangor has such fine photographs as one of the Emple clothing manufactory in 1920s, the Will B. & Edwin Smith's clothing store, the staff of the Bangor Public Library at the circulation desk of its new building, and a chorus line of little girl "rockettes" in Polly Thomas's dance school.[19] Many examples of the work of George French, whose photographs were designed to promote tourism to "Vacation-

land," were reprinted in a widely circulated book of the 1940s. He particularly continued the themes of the pre-war era—a cobbler repairing shoes, a woman ironing, a fisherman pulling off his boots, a woman writing by the light of a kerosene lamp, and a fisherman mending his nets. The same book includes a grand photograph by W. G. Macomber of a muscular Native American man in a headdress and holding a small child.[20] Eastman's book on the Sanford region includes a fine photograph by Mary Carpenter Kelley of Daughters of the American Revolution engaged in a Veterans Day commemoration. It amazingly evokes Grant Wood's famous painting.[21]

Documentary photography in Maine and the United States changed forever under the impact of *Life* magazine's photo essays. Surely the first major examples of that genre for Maine came from the photographers of the Farm Security Administration (FSA). In 1940–1942 photographers Jack Delano and John Collier, Jr., came to that same region illustrated in *In Fair Aroostook* to take publicity photographs of the work of the FSA. Delano photographed migrant workers in the great potato farms of the Caribou/Presque Isle region and the Acadian small farmers of the St. John Valley.

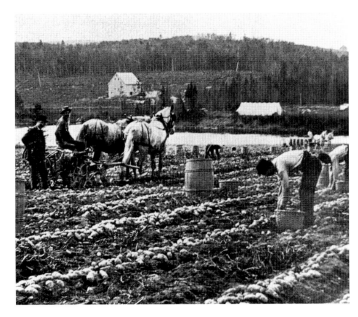

Fig. 15

On his way out of Maine, he photographed the trailer life and boarding houses scene of the emerging Defense Plant industry of the Bath Iron Works. His evocative photographs of lonely men in smoky bars in Bath have yet to be reprinted. Collier came to the Acadian St. John Valley in 1942 and 1943 to make superb essays of the Oneil and Irene Daigle family of Fort Kent and the Leonard and Emma Gagnon family of Frenchville.[22] As he left Maine, Collier made another fine photographic essay of Franco-American loggers on Brown Paper Company lands in the Rangeley Lakes region.

One of the most adept photoessayists in these years before the emergence of the Salt Center for Documentary Field Studies was Rockland's Kosti Ruohomaa (1914–1961). Ruohomaa, working with a Rolleiflex and 35-mm cameras, photographed for *Life* and other magazines in the 1940s and 1950s. Whether that life experience made him an "interested insider" or "interested outsider," he took some of the finest photographs of the Maine documentary tradition. Some of his best images of Maine include children silhouetted in a barn doorway, a man with a bucket returning from a barn in a snow storm, a man whipping oxen at a country fair ox pull, men around a stove in a general store, children in a school classroom, workers picking blueberries, and a woman in a hat speaking at town meeting (Figure 16). The latter photograph was part of a photographic essay on Maine town meetings. He did another great photographic essay on seagoing fishing. Nor should one forget his luminous image of "Night Train at Wiscasset Station."[23]

The transition from the *Life*-like photographic essay to the work Salt produces in its center and magazine surely came from two important photographers of the 1960s and 1970s. One was John McKee's book and exhibition, *As Maine Goes* (1966). It was a "turning point" in the Maine documentary tradition. He photographed United States Route 1 not long after Berenice Abbott did, but to a different effect. Abbott took many beautiful and artful photographs of her adopted state, but one is surprised that they have so little documentary content. She was a new arrival in Maine when

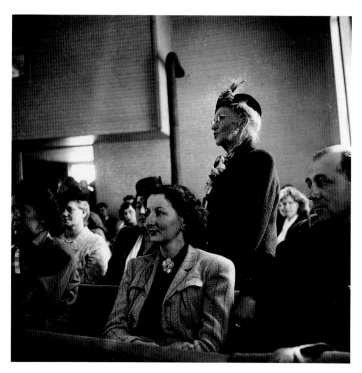

Fig. 16

she photographed Maine's coastal towns in the 1950s. That surely should have made her an "interested outsider." Yet her pictures seem to reveal an idealized version of Maine as a contrast to the New York from which she escaped. Perhaps she was too caught up in Maine's beauty to see its seamy side. McKee's work could see that side and it had enormous impact. When it appeared in 1966, the environmental movement was hardly underway. His image of a traditional street scene of Old Orchard Beach, complete with "no parking" signs, placed tourism in a new light (Figure 17). Other photographs in that book/exhibition exposed strip commercialism, litter, junk yards, the "no trespassing" signs that deny Maine people's access to the shore, and open sewer pipes into the ocean. The latter even included one from Acadia National Park's Blackwoods Campground.[24]

The other transition figure to Salt was Lynn Franklin. In combining photographs with oral interviews with ordinary Maine people, he sought to show "how fascinating is the story of an ordinary man or woman's life. " Particu-

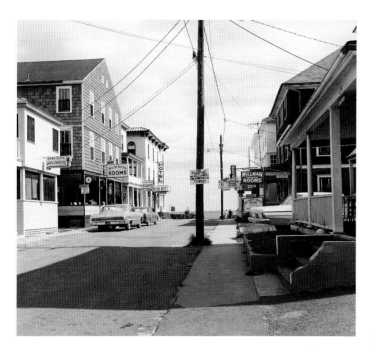

Fig. 17

cans Nick Ranco and Delia Daylight, photographed holding models of canoes they built.[25]

The birth of the Salt Center for Documentary Field Studies occurred in a period informed by such environmental concerns as McKee photographed. It, like the work of Franklin, was also informed by other concerns of that day—the civil rights movement and the ethnic revival, the back-to-the-land movement and interest in traditional rural values, and the valuing of ordinary people and their lives. Certainly, Salt established its own style and subject matter by combining text and pictures. They interact with each other, reinforce each other, complement each other. This essay has looked at Salt's forerunners. Some of them shared the center's concern for the ordinary, the rural, workers in the workplace, the ethnic experience. Rarely, however, did those forerunners combine photographs with text in the ways that have made Salt so important to the Maine tradition. Salt continues to set forth a new standard in the Maine documentary tradition.

larly strong were his interviews with Julian Cloutier, a Franco-American shop steward at Lewiston's Bates Mill, and with Native Ameri-

NOTES

The author thanks his University of Maine colleagues, PhD candidate in history Andrea C. Hawkes, reference librarian Melvin W. Johnson, and professor of folklore Edward D. Ives for their advice and assistance in writing this essay.

Illustrations are reproduced from the following lenders: Figure 1, courtesy of Lincoln County (Maine) Cultural Historical Association; Figure 2, courtesy of Geraldine Tidd Scott; Figure 3, courtesy of Special Collections, Fogler Library, University of Maine; Figure 4, courtesy of Acton-Shapleigh (Maine) Historical Society; Figure 5, courtesy of Thomaston (Maine) Historical Society; Figure 6, courtesy of Maine Folklife Center, University of Maine; Figure 7, courtesy of Stanley Museum, Kingfield, Maine; Figure 8, courtesy of Portland (Maine) Public Library; Figure 9, courtesy of Lewiston (Maine) Historical Commission; Figure 10, courtesy of Special Collections, Fogler Library, University of Maine; Figure 11, courtesy of Library of Congress; Figure 12, courtesy of Special Collections, Fogler Library, University of Maine; Figure 13, courtesy of Special Collections, Fogler Library, University of Maine; Figure 14, courtesy of Portland (Maine) Public Li-

brary; Figure 15, courtesy of Portland (Maine) Public Library; Figure 16, courtesy of Black Star Photography; and, Figure 17, courtesy of John McKee.

1. An excellent survey of holdings, needing to be updated, is Eric Flower, *State of Maine Photographic Materials in Maine Libraries* (Orono, Maine: University of Maine, 1972). In the 1970s, as an act of preservation, the University of Maine copied the historic photograph collections of such societies as the Kennebunkport Historical Society, the Bangor Historical Society, the Cutler Memorial Library, the North East Harbor Library, the Old Town Public Library and Old Town Historical Society, the Bar Harbor Historical Society, the Captain Prosser Collection of Sanford/Springdale, the Farris Collection of Searsport, the Milo Historical Society, the Stockholm and New Sweden Historical Societies, the Harrison Historical Society, the Lubec Historical Society, the Cherryfield/Narraguagus Historical Society, and the Silas R. Morse Collection of Livermore.

2. Michael Chaney, *The Photography of E. Joseph Leighton, 1884–1957*, brochure for an exhibit with

oral history at the Lincoln County Cultural and Historical Association, 1978. That association is custodian of the original photographic prints and glass negatives. A copy of the brochure, exhibition photographs, and oral histories are in the Maine Folklife Center, University of Maine, NAFOH numbers 1150–1151, 1178–1180, 1200–1201, 1204, and 1210, and photograph numbers 1922–2238.

3. Geraldine Tidd Scott, *Isaac Simpson's World: The Collected Works of an Itinerant Photographer* (Falmouth, Maine: The Kennebec River Press, 1990).

4. "Photos of Construction Work B[angor] & A[roostook] R.R. 1907," a leathercovered book of 138 consecutively numbered, roughly 6 1/2 by 4 1/2 inch photographs in "Photo Box," Special Collections, Fogler Library of the University of Maine. A copy of the Clement photograph of the daylight parade of the Ku Klux Klan in Milo, September 3, 1923, is available in the Maine Historic Photograph Collection, Fogler Library of the University of Maine, photograph numbers 0095-01/0095-02. The original print is in the Milo Historical Society. A photograph of a Klan rally, held in Dexter in 1925, appears in Dorothy A. Blanchard, "Into the Heart of Maine: A Look at Dexter's Franco-American Community," *Maine Historical Society Quarterly,* Vol. 33, No. 1 (Summer 1993), p. 30. The most recent reprinting of Clement's Ku Klux Klan picture was in the *Bangor Daily News,* May 20, 1994, p. C1.

5. Harland H. Eastman, *A Cluster of Maine Villages: Sanford and Springvale, Acton, Shapleigh and Alfred* (Sanford, Maine: Wilson's Printers, 1991).

6. Thomaston Historical Society, *Tall Ships, White Houses, and Elms. Thomaston, Maine 1870–1900* (Rockland, Maine: Courier-Gazette, 1976).

7. Marius B. Peladeau, *Chansonetta: The Life of Chansonetta Stanley Emmons, 1858–1937* (Waldoboro, Maine: Maine Antique Digest, 1977) and Abbie Sewell, *Message Through Time: The Photographs of Emma D. Sewell 1836–1919* (Gardiner, Maine: Harpswell Press, 1989).

8. Maine Folklife Center, University of Maine, NAFOH photograph number 300.

9. Holman Day, "The Queer Folk of the Maine Coast," *Harper's Magazine,* 119 (September 1909), 521–530.

10. Lewis Hine Collection, Prints and Photographs Division, Library of Congress, numbers 2443–2445. The Hine photographs from Eastport are numbered 2404–2436 and 2439–2459. Photographs from Lubec are numbered 2437–2438.

11. Ibid., numbers 709, 710, 718, and 719. The Hine photographs from Lewiston are numbered 707–719. Photographs of street scenes or crowds at noon hour at Goodall Worsted Co. and Sanford Manufacturing Co. of Sanford, Maine, are numbered 703–706.

12. *Lewiston: Image & Self-lmage of a Mill Town* (Lewiston Historical Commission, 1976), photograph number 59 in a catalog of an 87-image exhibition with introduction by Philip Isaacson.

13. Photograph from Archive Folio, William Underwood Co., in Special Collections, Fogler Library of the University of Maine; caption from Hine photograph number 2435, Library of Congress.

14. Clarence Pullen, In *Fair Aroostook* (Bangor, Maine: Bangor and Aroostook Railroad, 1902, and reprinted by the Madawaska Historical Society, 1972). Negatives, copied from the original book, are retained by the Maine Historical Photograph Collection, Special Collections of Fogler Library of the University of Maine, numbers 0001–18 to 0001–25.

15. Box 856, Great Northern Paper Co. papers, Special Collections, Fogler Library of the University of Maine.

16. *Eighth Annual Report of the Bureau of Industrial and Labor Statistics for the State of Maine, 1894* (Augusta, Maine: Burleigh and Flynt, 1895), unnumbered page opposite p. 133.

17. See, for example, Edward D. Ives' *Argyle Boom* (Orono, Maine: Northeast Folklore, XVII, 1977) and C. Stewart Doty, *First Franco-Arnericans: New England Life Histories from the Federal Writers' Project, 1938–1939* (Orono, Maine: University of Maine Press, 1985), pp. 47–101.

18. Walter G. Hay, *Thru Maine by Camera* (n.p., Seavy Co., n.d.).

19. Abigail Ewing Zelz and Marilyn Zoidas, *Woodsmen and Whigs: Historic Images of Bangor, Maine* (Virginia Beach, Va.: The Donning Company Publishers for the Bangor Historical Society, 1991).

20. Keith Warren Jennison, *The Maine Idea* (New York: Harcourt, Brace and Co., 1943).

21. Eastman, *A Cluster of Maine Villages*, p. 93.

22. C. Stewart Doty, *Acadian Hard Times: The Farm Security Administration in Maine's St. John Valley* (Orono, Maine: University of Maine Press, 1991). The Fogler Library of the University of Maine has microfilm of the Maine photographs taken by Delano and Collier.

23. Lou Dietz with photographs by Kosti Ruohomaa, *Night Train at Wiscasset Station* (Garden City, New York: Doubleday, 1977). The Farnsworth Museum, Rockland, Maine, has a collection of Ruohomaa's work.

24 John McKee, *As Maine Goes* (Brunswick, Maine: Bowdoin College Museum of Art, 1966). One might particularly contrast McKee's work with Abbott's photograph of a Belfast house on Route 1 as reprinted in Hank O' Neal, *Berenice Abbott: American Photographer* (New York: McGraw-Hill, 1982), p. 235.

25. Lynn Franklin, *Profiles of Maine* (Waldoboro, Maine: Maine Antique Digest, 1976). Nearly 70 of Franklin's interviews are in the Maine Folklife Center, University of Maine.

SALT, THE FSA, AND THE DOCUMENTARY TRADITION

James C. Curtis

For more than half a century, scholars and critics have praised Farm Security Administration photographs as objective documents that captured the reality of American rural life during the Great Depression. The images of FSA stalwarts Dorothea Lange, Walker Evans, Arthur Rothstein, and Russell Lee are now as famous and familiar as the Civil War photographs of Matthew Brady, the tenement revelations of Jacob Riis, and the industrial exposés of Lewis Hine. As the fame of the FSA grows, so do the reputations of project photographers, who are now likened to anthropologists or ethnographers.[1] Because the FSA file contains two extensive series on Maine agriculture, the natural assumption is that these images represent an intensive examination of rural culture and therefore establish a model to which the work of Salt should be compared. A brief analysis of the origin and process of FSA photography provides a necessary preface to such comparison.

Like Salt, the FSA photographic enterprise grew from modest beginnings. Founded in 1935, the project was originally designed as an adjunct of the agency's information division. Photographers were assigned to take pictures of government relief efforts in the countryside, particularly areas of the South and the far West hardest hit by the Depression. The FSA envisioned the resulting photographs as natural illustrations for reports to Congress. The FSA's audience expanded considerably in the late 1930s, thanks in part to the founding of such powerful illustrated magazines as *Life*

and to the popularity of documentary films. The FSA photographic file eventually comprised more than 80,000 prints. This growth resulted from political pressures as well. Project director Roy Stryker repeatedly encountered charges that he was manufacturing propaganda and that the government had no business subsidizing picture taking. Stryker defended his work as an exhaustive, objective examination of conditions in rural America. He characterized his photographers as historians with cameras and argued that the FSA was compiling a historical archive. Scholars have tended to take Stryker at his word. They have overlooked the fact that the majority of FSA photographs depicted federally sponsored projects and that a high percentage of subjects were current or prospective relief recipients.[2]

At first glance, Salt appears the antithesis of the FSA. Bound to Maine for its entire twenty-two-year history, the Center eschewed national topics in favor of local ones. Teenage exuberance, not federal funds, fueled Salt's early documentary investigations. FSA photographers were paid professionals; Salt's students were amateurs. Like the FSA, Salt examined rural scenes but concentrated on urban ones as well. Salt photographers moved freely between field and factory, lumber camp and fish market, hunting lodge and YMCA. Migrants, "Mainiacs," homesteaders, the homeless, tattoo artists, and tourists constitute but a small segment of the diverse cast that has walked across Salt's stage.[3]

For all its apparent eclecticism, Salt has long employed a method of fieldwork that extends and enriches the documentary standards first established by the FSA. The taped interviews and field photographs that are the byproducts of such inquiry form the basis for an intensive learning experience. To be sure, Salt photographers enter the field with preconceptions. But their constant reworking of data, openness to new evidence, and determination to pursue a subject in exhaustive detail lead inevitably to a reexamination of their original assumptions. In other words, words borrowed from ethnography, Salt fieldworkers are "participant observers." To get the inside story, they must stand close to their subjects; the closer they stand, the more texture and meaning their narratives develop. Time is Salt's ally. For the FSA, time was a formidable foe. Stryker's photographers rarely spent more than a day or two in any location; a week devoted to a single assignment was a luxury. There was no time for reflection, reevaluation, or revision of the prescribed agenda for a story. FSA photographers arrived at the scene as outsiders, and outsiders they remained. The FSA's two visits to Maine provide perfect cases in point.

The FSA photographic project was nearly five years old when Roy Stryker turned his attention to Maine. In October 1940, Jack Delano made a hurried tour of the St. John River Valley in the Northeastern corner of the state. Two years later, another of Stryker's photographers, John Collier, completed a second series on the potato fields of Aroostook County. Both Delano and Collier focused on Acadian farmers.[4] Why make two visits to the same remote locale? And why concentrate exclusively on the same small band of French Canadian families? Given Stryker's professed commitment to history and historic preservation, the answer seemed simple enough. He sent his two staff members to record the details of a distinctive ethnic community whose traditions stretched back to the 18th century. But nowhere in his instructions to his photographers did Stryker mention history or ethnicity. Nor did the photographic series dwell on Acadian customs. Quite the contrary, Delano and Collier presented the Acadians as typical American farmers. Perhaps Stryker's insensi-tivity to ethnicity was the product of the moment. With war raging in Europe, there was no time to record regional distinctiveness and every reason to emphasize national unity.

The philosophy underlying the FSA's coverage in Maine was not simply a wartime expedient. Since his days as a Columbia University economics instructor, Roy Stryker had believed in the American farm as a primary symbol of the nation's unique heritage. As he had learned about agriculture from graduate seminars, so he required his photographers to consult key texts before they went on assignment. At the top of Stryker's required reading list stood J. Russell Smith's *North America* (1925), a geographical primer that advanced a deterministic view of culture. Smith portrayed *North America* as a unique and demanding environment that brought forth a new breed of citizens, different from and superior to their Old World forebears.[5]

Smith's definition of American exceptionalism provided Stryker with a number of convenient strategies for photographic fieldwork. In responding to a steady stream of requests for photographs of soil erosion, dust storm damage, the plight of sharecroppers, and the travails of migrant workers, Stryker did not hesitate to concentrate on gritty details of rural poverty. Such images promoted public awareness of the need for relief. Yet Stryker's photographers took great care to present relief recipients as innocent victims, temporarily at the mercy of the natural elements (Figure 1). They were not members of an emerging underclass. In their essential relationship with the land lay their strength and their salvation. Centuries of toil with the demanding environment had endowed them with an unshakable work ethic and the virtue of self-reliance. Since the Depression was yet another of the natural cycles described by Smith, there would be an eventual return of prosperity and no further need for relief.[6]

North America also addressed public anxieties about ethnicity, albeit in a somewhat roundabout way. Smith advanced the argument that the peopling and cultivation of the continent had transformed European immigrants into Americans. By locating the essence

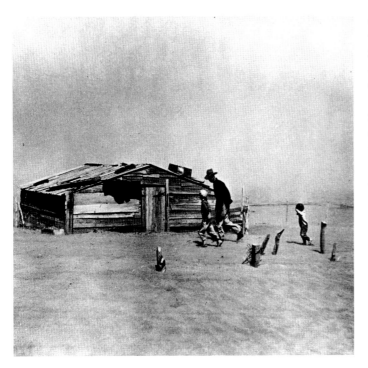

Fig. 1

counter Lynd's findings that urbanization had undermined family cohesion.[8] Over the next four years Stryker's photographers amassed a large file of images praising cohesive rural communities and stable farm families.

Stryker regarded New England as the ultimate repository of these agrarian ideals. No doubt part of his affection resulted from the summer vacations he spent in Vermont. Yet J. Russell Smith made constant reference to America's proud heritage of Yankee independence and industry. It was therefore in celebration of these virtues that Stryker sent Jack Delano to cover the fall harvest in New England from Connecticut to Maine.

"Emphasize the idea of abundance," Stryker instructed his young staffer, urging him to photograph "the 'horn of plenty' and pour maple syrup over it . . . mix well with white clouds, and put on a sky blue platter." Stryker knew what to do with these pictures of "cornfields, pumpkins, raking of leaves, roadside stands with fruits of the land."[9] What better way to give thanks for being spared the horrors of war than to celebrate the agrarian traditions that constituted America's first line of defense?

By the time Jack Delano arrived in Aroostook County, he had already tested Stryker's formula. In the tobacco fields of central Connecticut, he took a series of photographs of a Polish farm couple, rejoicing in the completion of the harvest (Figure 2). Delano's apparent purpose here was to demonstrate that farming had provided more than material plenty; the land had given these individuals a new national identity. Patriotism and loyalty to the agrarian ideal of self-sufficiency were keynotes in Delano's photographs of two other ethnic farm families: a Jewish poultry producer and an Italian farmer, both residing on the outskirts of Colechester, Connecticut. In photographing the interior of their farmhouses, Delano avoided any visual reference to ancestral relics or ethnic artifacts.

The potato harvest was in full swing when Delano arrived in the St. John River Valley. "This is a rather strange area," he wrote back to Stryker. "Because of the closeness to Canada and the strange history of the Acadians there

of Americanism in a shared set of agrarian traditions, born of the land and passed on to subsequent generations, Smith effectively denied the influence of European prototypes. American fears of foreigners and foreign influence reached crisis proportions in 1939 with the outbreak of war in Europe. Stryker's staff rushed ahead with publication of an extended pictorial essay, praising America as a democratic haven. Published in 1940, the same year Stryker dispatched Jack Delano to Maine, *Hometown* blended positive FSA images of rural life with a poetic text by Sherwood Anderson.[7]

For Stryker, *Hometown* culminated a quest begun in 1936 when he met with Robert Lynd, author of the sociological classic *Middletown* (1929). Fascinated by Stryker's work, Lynd wondered whether rural communities had maintained traditional values that had disappeared in Middletown's headlong rush to materialism. In response to Lynd's promptings, Stryker developed a series of "shooting scripts" on rural domestic life. He ordered pictures of rural Americans "at home in the evening," gathered around the dinner table or listening to the radio. These images were designed to

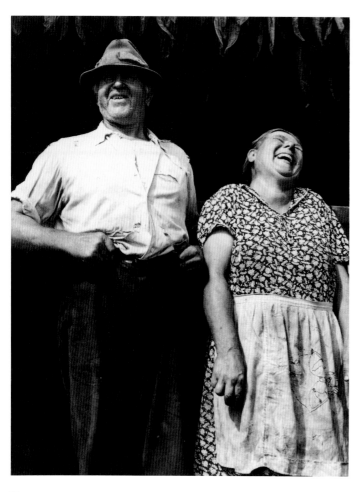

Fig. 2

Fig. 3

is a large population of French Canadians along the St. John River." Delano went on to comment that "the towns and homes and church architecture show the influence of a different people than one finds in the rest of the state."[10] If the Acadians looked foreign to Delano, his photographs portrayed them as typical American farmers. His portrait of Claude Levesque differed little from the pictures of Polish tobacco farmers in Connecticut. (Figure 3). Delano carefully arranged this closeup to suggest strength and competence. Levesque's rugged work clothes, substantial boots, and grimy hands testified to a life of hard work. By deciding to shoot up at his subject, Delano avoided any suggestions that Levesque had been beaten down by the elements. Delano chose a similar angle for his photograph of another Acadian farmer, Zephirin Gendreau (Figure 4). Again he emphasized strength and mastery of the

land. Gendreau's clothing made little reference to regional distinctiveness. Rather his battered fedora linked him to thousands of other American males of the Depression era.

The themes of strength and self sufficiency dominate Delano's interior photographs as well. He designed the family gathering shown in Figure 5 to approximate a Thanksgiving dinner. By standing behind and to one side of the father, Delano was able to show all family members and to record the table's bounty. In the caption to this image, the photographer highlighted the role of the male as provider by writing that the meal came after the farmer "and the boys [had] finished a day's work in their small potato fields." Delano's caption explained the apparent incongruity between the father's torn work shirt and the more formal attire of the other family members. He included that detail as visual proof of the man's

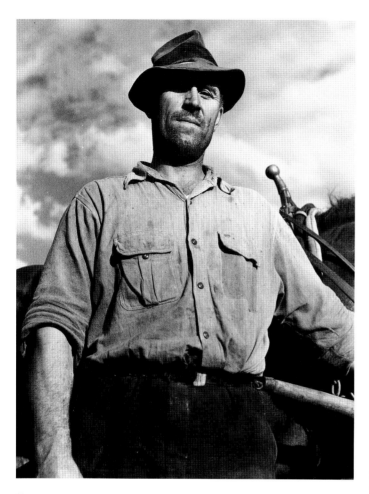

Fig. 4

ner" is itself misleading. Rural dinners usually occurred at noontime, not at the end of the work day. Did Delano simply misspeak in his caption? Did he really mean to say that this was a supper? Perhaps. But labeled as it was, this photograph had added meaning to urban Americans who *did* have dinner in the evening, after they "had finished a day's work."

Cultural norms and societal expectations also governed Delano's depiction of Acadian women. Where he showed men as masters of the land, Delano confined women to the interior world of the farm. His composition of a farmer's wife seated at the sewing machine, her young child perched precariously by her side, incorporated symbols long used by the FSA to suggest the importance of women's domestic roles (Figure 6). Searching again for the proper angle of vision, Delano located his camera (and therefore the viewer) in the living room, looking through the open doorway into the kitchen. Before focusing on subjects in the kitchen, the viewer must first note the spinning wheel and above it the ancestral photograph. Historical icons, these artifacts testified to the process of education and the transmission of tradition. The lessons one generation learned on the spinning wheel were in turn passed on to the next generation where the sewing machine became the site of instruction. Ironically, the sons of the farm wife pictured here told a later interviewer that she made little of her family's clothing and used the machine mainly for repair of torn items.[12] By associating women's work with such traditional domestic machines as looms, spinning wheels, sewing machines, and woodburning stoves, Delano greatly underestimated the scope of female labor on the Acadian farm. During the long winters, Acadian wives often assumed total responsibility for house and farm because their husbands were away working in the mills or in the woods.

While it took the FSA four years to discover the rich photographic potential of Aroostook County, less than half that time elapsed before Roy Stryker sent another young photographer, John Collier, on a return visit to the St. John Valley. Collier's trip began in August 1942, and followed an itinerary that was a carbon copy of Delano's visit twenty-two months

hard work. This angle of vision also allowed Delano to suggest that the father was saying grace, when in fact the family had already begun to eat, everything that is save the potatoes, strategically placed in the center of the table. Apparently, Delano intended the viewer to consume this course as proof that in rural America families could still live off the land.

In his determination to use the family dinner as a metaphor for agrarian self-reliance and resilience, Delano created an artificial scene, in which national symbols replaced local ones. Acadians did have distinct food ways. All but hidden by the coffee pitcher was a plate of buckwheat "ployes." These flatbreads were French in origin and different from American "flapjacks" in being cooked only on one side. Delano's caption makes no mention of "ployes," nor of any other items on the dinner menu.[11] In fact, his use of the term "din-

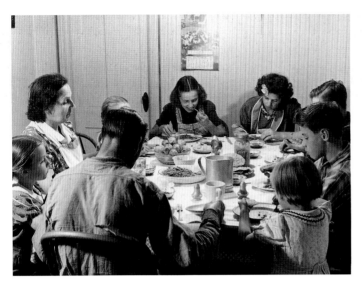

Fig. 5

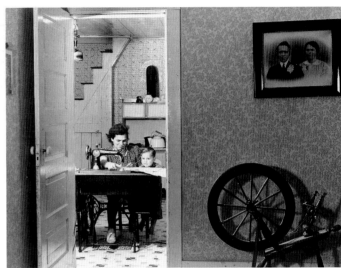

Fig. 6

earlier. Collier started in rural Connecticut, where he concentrated on farmers with immigrant backgrounds. But where Delano's photographs touched on ethnicity in a tentative way, Collier dropped all subtleties and designed images to demonstrate that farmers with immigrant backgrounds were patriots to the core and fully supported the war effort. The added sense of national urgency resulted from the transfer of the FSA photographic project to the Office of War Information, a transfer that took place while Collier was making his way northward. Collier constructed another series to demonstrate that America could depend on the loyalty of Russian immigrants as well. Collier focused on Boris Komorosky, a potato farmer who had graduated from the "Czar's naval academy" and served as a lieutenant commander in the U.S. navy during World War I. Collier's extended captions failed to explain why Komorosky abandoned the sea. Instead, the harvest photographs testified to the success of the Russian's new career. The interior scenes showed Mrs. Komorosky making her contributions to the war effort by preparing bandages for the Red Cross. Even the couple's young son did his part by pasting stamps into his savings bond album.[13]

Once he arrived in Aroostook County, Collier continued to feature children as an integral part of the family unit and as enthusiastic participants in self-sufficient agriculture. "Children

help with much of the work in the fields," Collier wrote in the caption of a photograph of a young Acadian girl at the reins of a horse-drawn hay rake (Figure 7). Unlike most of Collier's Acadian photographs, this image was the result of a chance encounter. Collier was driving down a dirt road when he saw the young girl in the field.[14] Neither she nor mem-

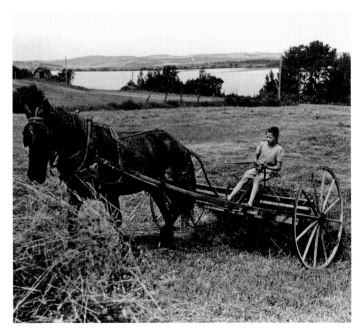

Fig. 7

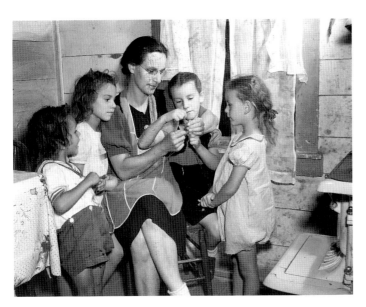

Fig. 8

bers of her family appeared in any other Collier photographs. While this image testified to the hard work that children often performed on the farm, the image was troublesome in its implications, for this young girl was working in the field, an arena that Collier and his colleagues normally reserved for the male members of the family. After the outbreak of World War II, farmers were often designated as essential workers and granted exemptions from military service. Even though there was widespread recognition of the need for such exemptions, the subject of farm labor and the selective service remained controversial. This public sensitivity helps explain why Collier devoted a majority of his images to internal domestic scenes. The photographer arranged to have one Acadian housewife demonstrate three separate household tasks: cooking on a wood stove, making butter and spinning wool. Each image presented a powerful statement about female competence and the transmission of skills from mother to daughter. When looked at together, however, the images reveal Collier's haste. The farm wife wore the same dress and apron throughout the entire series.[15] Collier was also rushed as he composed a picture of an Acadian woman providing instruction for her offspring (Figure 8). In the caption for this image he claimed that "daughters of the industrious Acadian farmers learn to knit as soon

as they learn to walk." Unfortunately, the youngest child shown on the left was a boy.[16]

Before leaving Aroostook County, Collier paid a visit to the local Catholic school at Lille, Maine. Once inside the building, Collier confronted several problems. From all indications, the instruction, especially in this catechism class, took place in French (Figure 9). By having the teacher point to a religious poster with English text, Collier circumvented any potential question about the upbringing of these children and whether their parents conversed in English or maintained the traditional French. In a companion image of young boys in another area of the school (Figure 10), Collier provided a much less ambiguous answer to the question of whether Acadian loyalties outweighed American patriotism. "Though Acadian boys are farmers by tradition," Collier wrote in his caption, "like all other boys in America they are 'air minded'."[17]

In the upper right-hand corner of this photograph there is a small sign that says "Help Uncle Sam." This is precisely what Collier's photographs were designed to do, and he enlisted the Acadians in this cause. In the process, he removed many traces of their culture. He did so not out of malicious intent or

Fig. 9

Fig. 10

even because of insensitivity to the distinctiveness of Acadian culture. Rather he operated in great haste to create usable images that could demonstrate that Americans everywhere in the country supported the war effort.

John Collier left Maine in the late summer of 1942. Fifty years later, Amy Toensing, a student at the Salt Center, returned to the fields of Aroostook County. Like Delano and Collier before her, Toensing came to cover the harvest (Figure 11). Her assignment reveals the marked difference between the documentary approach pioneered by the FSA and the tradition as carried on today under the auspices of Salt.[18] Working from predetermined shooting scripts, Collier and Delano had concentrated on government clients and designed images to show the positive impact of federal relief. They also generated pictorial publicity to support the war effort. Neither Delano nor Collier could afford to spend more than a few days in any location.

Toensing was free of such political pressure and time constraints. Like other photographers at the Salt Center, she pursued a topic of her own choosing. In deciding to feature the role of migrant labor in the broccoli harvest, Toensing covered familiar terrain. The FSA file contains thousands of images of migrant workers, none more famous than Dorothea Lange's 1936 portrait entitled "Migrant Mother" (Fig-

ure 12). That Dorothea Lange took this picture—indeed the entire six-picture series—in less than ten minutes is now regarded as evidence of her genius, and not as a commentary on the haste of FSA photography.[19] Amy Toensing spent weeks, not minutes, in the broccoli fields of the St. John Valley. She took more than two thousand images during her stay, nearly twice the number of photographs Walker Evans made in his two-year career with the FSA. She employed the camera in much the same way that modern ethnographers use a tape recorder, to gather information that must then be sifted and evaluated before more pictures are taken. And in the layering of image upon image, interview upon interview, a story began to emerge. The Salt Center has long recognized that stories take shape in the field and frequently involve an interaction between a photographer and a writer.

Kristin Atwell went to Aroostook County with Amy Toensing to write of the experiences of the Mexican and Filipino migrant crews. Unlike their FSA predecessors, Atwell and Toensing were determined to record the distinctive sights and sounds of ethnic cultures that at first left them baffled. "I slaughter their subtle language," Atwell wrote of her first discussions with Filipino migrants. But her linguistic fumblings produced good humor and gave her greater access to the interior of the migrant world.

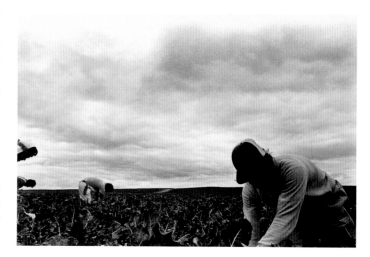

Fig. 11

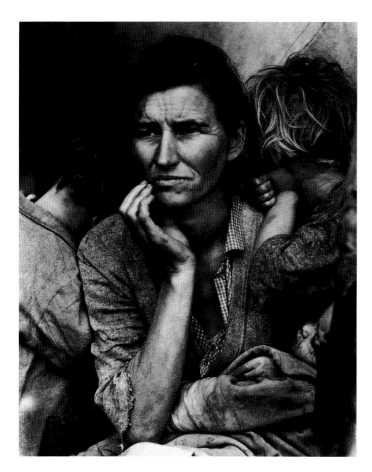

Fig. 12

dent who saw migrant labor in a more positive light. "I think the economy needs the migrant worker, because . . . average Americans will not do the kind of labor that migrant workers will do."

Although the majority of their essay dealt with the attitudes, work ethic, and family values of the migrants, Atwell and Toensing also appraised the outlook of Aroostook County farmers. Here again the Salt team told a more complex story than their FSA predecessors. Atwell and Toensing found residents who still subscribed to the agrarian ideal that was the focal point for Delano and Collier. One farm

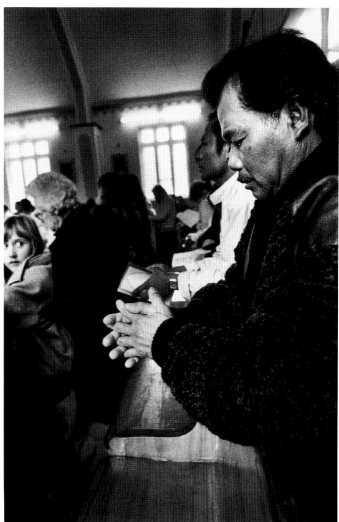

The resulting pictorial essay in *Salt* stands in sharp contrast to the idealized farm scenes recorded by Delano and Collier half a century earlier. Ethnic heritage and traditions provide a rich texture missing in the FSA study. Toensing's photograph of Hermino and Conrad at St. Louis Church calls attention to the importance of religion in this rural area and to the church as a meeting place between migrant workers and the county's permanent residents (Figure 13). In the sidelong glance of a child, Toensing captures some of the suspicions generated by the annual influx of migrant workers. Where Delano and Collier had chosen to ignore migrant labor and its attendant tensions, Atwell's narrative gives voice to this ambivalence. "Why do these people keep staring at us?" asked one of her respondents. "It's like they have never seen Mexicans before." Atwell balanced these comments with those of a resi-

Fig. 13

wife looked back to the days when families had "six or seven kids and they all worked. It was a romantic idea, a really wholesome lifestyle." But the tone of the conversation changed when the family discussion shifted to the subject of federal assistance. Gone were references to idyllic harmonies and familial traditions. One elderly respondent remembered being forced to take out a government loan with disastrous results. "They tell you when to plant, how much you can plant. You're not making your own decisions any longer. So it was just self-defeating . . . you can't compete with the government."[20]

The Salt Center has been competing with the government—or more precisely the ghost of the FSA—for more than two decades. Like the FSA, Salt provides a central location for darkroom facilities. But in the use of the darkrooms, Salt has gone far beyond its government predecessor. Stryker's photographers rarely developed their own negatives or made their own prints. They often mailed their exposed film to Washington, where technicians prepared contact sheets. Stryker insisted that photographers use these contact sheets to prepare captions, but he reserved to himself the right to select those negatives to be printed for the file. As a consequence, nearly two-thirds of the FSA negatives have never been printed. They remain in the custody of the Library of Congress but are unavailable to scholars. Nor did Stryker retain contact sheets. At Salt, the development of negatives and the making of prints is an integral part of the learning process. Salt's photographers, students and faculty alike, do their own darkroom work. Contact sheets are subjects for wide-ranging discussions about the esthetics of camera work and the content of the assignment. These evaluation sessions constitute the core of the Salt photographic curriculum. At the conclusion of each semester, all of the negatives, prints, and contact sheets are deposited in the Salt archive, where they will remain for use by future students and scholars.

In his essay in this book, Todd Hoffman, Salt's director of photography, refers to his young students as "rookies." Some begin with very little practical knowledge. Like the FSA's Arthur Rothstein, barely twenty-one when he joined Stryker's staff, Salt's undergraduate and graduate students learn by a process of immersion in photography and fieldwork. But unlike Rothstein, they study in an educational environment, free from the political and bureaucratic pressures that shaped the FSA file. Above all, they select their own topics, develop their own research methodologies and present their discoveries as personal, not corporate, narratives. They arrive at Salt as "outsiders" (to use C. Stewart Doty's term); by the time they leave they have gained a sense of place. They have seen Maine from the inside, and their insights affirm the vitality and provide new energy to the documentary movement.

NOTES

Illustrations are reproduced from the following lenders: Figure 1, courtesy of Library of Congress; Figure 2, courtesy of Library of Congress; Figure 3, courtesy of Library of Congress; Figure 4, courtesy of Library of Congress; Figure 5, courtesy of Library of Congress; Figure 6, courtesy of Library of Congress; Figure 7, courtesy of Library of Congress; Figure 8, courtesy of Library of Congress; Figure 9, courtesy of Library of Congress; Figure 10, courtesy of Library of Congress; Figure 11, courtesy of Salt Documentary Archive; Figure 12, courtesy of Library of Congress; and Figure 13, courtesy of Salt Documentary Archive.

1. There is an extensive literature on the FSA photographic project that is summarized in Penelope Dixon's *Photographers of the Farm Security Administration: An Annotated Bibliography 1930–1980* (New York, Garland Publishing, 1983). The standard history of the FSA photographic project is F. Jack Hurley, *Portrait of a Decade* (Baton Rouge, Louisiana State University Press, 1972). Of the many published collections of the FSA, *Documenting America* (Berkeley, University of California Press, 1988) provides superb reproductions and penetrating analysis of both the project and some of its most famous assignments. For an evaluation of the FSA's much-heralded commitment to realism and documentary honesty, see James C. Curtis, *Mind's Eye, Mind's Truth, FSA Photography Reconsidered* (Philadelphia, Temple University Press, 1989).

2. The standard view of the FSA photographic archive as a repository of revealed truth was set forth at length in Hurley, *Portrait of a Decade,* and reinforced by William Stott's evaluation of the entire documentary movement in *Documentary Expression and Thirties America* (New York, Oxford University Press, 1973). For an alternative evaluation of Roy Stryker's philosophy and bureaucratic mindset, see Curtis, *Mind's Eye, Mind's Truth,* Chapter 1.

3. The research activities of Salt are ably set forth in two of the Salt Center's books: Pamela Wood, ed., *The Salt Book* (Garden City, New York: Anchor Press/Doubleday, 1977), and Pamela Wood, ed., *Salt 2* (Garden City, New York: Anchor Press/Doubleday, 1980), as well as in the center's magazine, *Salt,* published in cooperation with the University of Maine at Farmington.

4. In *Acadian Hard Times: The Farm Security Administration in Maine's St. John Valley. 1940–1943* (Orono, Maine, University of Maine Press, 1991), C. Stewart Doty provides a model analysis of the FSA's activities in Maine. Indeed, this is the finest of several state studies of FSA photography. In the quality of photographic reproduction and the extensive use of interviews with families depicted in FSA photographs, Doty's book is reminiscent of another powerful regional study: Bill Ganzell's *Dust Bowl Descent* (Lincoln, Nebr.: University of Nebraska Press, 1984). Like Ganzell, Doty presents a penetrating analysis of the cultural and economic conditions that prompted Stryker's assignments.

5. J. Russell Smith, *North America: Its People and the Resources, Development, and Prospects of the Continent as an Agricultural, Industrial and Commercial Area* (New York: Harcourt, Brace, 1925). The only study of Smith's scholarship is Virginia M. Rowley, *J. Russell Smith: Geographer. Educator and Conservationist* (Philadelphia: University of Pennsylvania Press, 1964). On Smith's influence on Stryker, see Charles A. Watkins, "The Blurred Image: Documentary Photography and the Depression South" (dissertation, University of Delaware, 1982), pp. 57–63.

6. For a superb survey of 1930s culture that highlights the era's tenacious optimism see David Peeler, *Hope Among Us Yet: Social Criticism and Social Solace in Depression America* (Athens, Ga.: University of Georgia Press, 1987).

7. Sherwood Anderson, *Home Town* in *The Face of America,* ed. Edwin Rosskam (New York: Alliance Book Corporation, 1940).

8. Robert S. Lynd and Helen Merrell Lynd, *Middletown: A Study in Contemporary American Culture* (New York: Harcourt, Brace, 1929).

9. Roy Stryker to Jack Delano, September 12, 1940, Roy Stryker Collection, Photographic Archives, University of Louisville (hereafter RSC).

10. Delano to Stryker, October 24, 1940, RSC.

11. Doty, *Acadian Hard Times,* pp. 117, 133.

12. Doty, *Acadian Hard Times,* p. 91.

13. John Collier, captions for photographs of the Komorasky family, Lot 37, Reel 4, Farm Security Administration Photographic File, Library of Congress (Microfilm).

14. Doty, *Acadian Hard Times,* p. 158.

15. John Collier, photographs of the Gagnon family, August 1942, Farm Security Administration, negative numbers, 83758–C, 83669C, 83679–C, 83688–C, 83692–C, 83700–C. This series appears in Doty, *Acadian Hard Times,* pp. 116–120.

16. John Collier, caption for photograph, negative number 83715–C. In *Acadian Hard Times,* p. 137, Doty provides the correct names of the children in this photograph.

17. John Collier, caption for photograph, negative number 83633–C.

18. Kristin Atwell, "Broccoli Harvest," photographs by Amy Toensing, *Salt,* No. 44 (December, 1993), 20–45.

19. For a guide to literature on Dorothea Lange and a reassessment of her most famous photograph, see Curtis, *Mind's Eve, Mind's Truth,* Chapter 3.

20. Atwell and Toensing, "Broccoli Harvest," pp. 28, 38, 43–44.

THE FORM OF FUNCTION

SALT DOCUMENTARY PHOTOGRAPHY

R. Todd Hoffman

PEOPLE HAVE been making and collecting photographs at Salt for over twenty years. Almost 200 of us have produced over 250,000 photographic images in a quarter of a century. They're the kind of photographs we think show it like it really was—even if for only a thirtieth of a second. This is not to suggest that we are injecting our photos with the responsibility of showing "truth" or being purely objective. But we think they are truthful depictions of people, places, and things in Maine.

In large part, Salt photographs in this book and our archive are made by people we might call rookies—talented but largely inexperienced photographers—about half of whom are college graduates, the other half advanced undergraduates. And yet the work done at Salt is of a high degree of credibility for reasons I want to talk about. One is that the archive has, as lynchpins of quality, an abundance of work by some exceptional professionals.

The work of Lynn "Kip" Kippax, Jr., the first director of photography at Salt, set photographic and technical standards that are the bedrock of Salt's own documentary traditions. Kip's imagery is direct and true to the scene with strong if simple compositions. Pam Berry's and Tonee Harbert's work as photographic fellows in the late 1980s contributed a broader reach of photographic style to a series of subjects. My own photography (1990–present), I would hope, exemplifies my intent to balance a signatured sensitivity to form with an appreciation of history. However, my main influence is probably more pedagogical and editorial, shaping the documentary methods and discipline at Salt.

A second, and even more important, reason for the credibility of the Salt documentary photography has to do with goals and methodology. The uniqueness of the individual photographer's contribution to the archive—from professional to student or gifted to simple enthusiast—is mitigated and often superceded by significant common shaping influences. One is the medium itself and its unique influence on any message it transmits.

Photography as a medium is well suited to feed the dialectic battle of the brain—the left side/right side thing. The analytic versus the creative. On the one side, a photo is a scientific two-dimensional rendering of a moment in time that can communicate intellectually certain identifiable facts. On the other side, it's a graphic, a visual declaration about the world the photographer sees and feels in an abstracted form. That declaration creatively engages our senses and emotions, taking a viewer well beyond its physical two dimensions, well beyond its scientific application. The most successful photographers have been the ones that succeeded in serving both of these two functions of photography. This dichotomy is a crucial part of the tradition of documentary photography shaping our photo work at Salt.

In the early 1860s, the appeal of Matthew Brady's photographs of the battlefields of the

Civil War was based on the awful truthfulness of these photographs, "views" as they were called. Ironically, there is strong evidence that certain scenes of carnage photographed were set up to project the esthetic or moral—we can only guess—*views* of the photographers.[1]

To working photographers at Salt, these battlefield tamperings offer the core of our dialectic tuggings. If one's goal is to photograph authentically, which photograph serves best? The photograph that is most purely factual of *how things really looked*? Or, as in Brady's case, the photograph that is most evocative of the stench of death and *how things really were*? And to carry this quandary a step farther, what if how things look in a photograph isn't how they really look in the field? Where is that truth? What responsibility does the Salt photographer have in reconciling the photograph to what he or she sees?

Fifty years after Brady, Alfred Stieglitz, a photographer and intellectual of the first order, fathered the idea of the photographic equivalence—the notion that a photograph of one thing could evoke the emotional response of something else. This concept offered photographers new license. No longer was "truth" solely defined by what was in front of the camera. What is communicated by the picture is at least as important.

This dialectic tension frequently sets documentary photography off from other kinds of photography. People often think of photojournalism as documentary and vice versa. It is not necessarily so. Over the decades photojournalistic practice has been as influenced by the demands of art and the ability of its pictures to entertain and sell publications as it has been by the needs of historic authenticity.

In the late 1930s, by the time millions of paying consumers were lining up to buy *Life* magazine—"to see life; to see the world; to eyewitness great events; to be amazed; to be instructed" as its motto read, one can easily imagine that megabuck publishing pressures to sell magazines frequently took precedence over photographic veracity at Time/Life. Big money and big egos feeding enlarged public expectations brought big pressures to bear on journalistic practices. When amazing pictures were demanded on deadline with acceptable

editorial perspectives and technical qualities, photographs too often had to be made—that is set up, correctly lit, and shot to look real.[2] Even *National Geographic* has been known to move Egyptian pyramids within a photo (digital reimaging) in order to fit them into the dimentions of Geographic's cover design.[3] And during the 1994 Olympics, *Newsday* fabricated a photo of figure skaters Tanya Harding and Nancy Karrigan skating next to each other for its cover story, even though it never happened.

It is this staging of photographic subjects—this setting up of the scene, or even more manipulation, the reimaging of components from more than one scene—that is an important point of departure between documentary work as we define it and photojournalism.

Another frequent point of departure between much documentary work and photojournalism is film choice. While there is no canon restricting documentary work to black and white, generally there is a predisposition to the medium. For starters, we're used to it—it's traditional. Black and white photography came first by over a half a century. Even when color films arrived, they were less stable. Their colors shifted with time. And their inconsistent tonalities made them more suitable for less serious photography—family snapshots or, if professionally used, commercials. Although technical improvements have been made, color photography remains problematic when recording artificial light. While our eyes are very forgiving of the color shifts of incandescent, fluorescent, mercury vapor lights, and so forth, films aren't. They record with accuracy the light source temperatures in color. They record what we don't see, and that makes it very hard to show it like it was. Journalists who routinely use their own light sources—flash and portable studio lights—to rectify this technical problem dramatically change how things looked.

The nontechnical challenge to using color in documentary work is that it packs its own content. Different colors affect us differently emotionally and psychologically. Most often this color content is quite independent of the historical content and can be quite contradictory.

All that being said, there have been some wonderfully successful uses of color in documentary work, where color and especially the

color of the light is very much a part of what one is photographing. Alex Webb's work in the Caribbean tropics looks as hot as it feels. Bruce Davidson's evocative photographs of New York City subways are brilliant declarations of the colorful humanity that passes through the maze of platforms, stairwells, halls, and speeding train cars.

The exceptions aside, black and white photography continues to be most often considered more authentic than color. While the resilience of tradition plays a part, visual simplicity plays a big part too. Most often, black and white speaks more directly to the issues. It is interpretively less complex. Even as it changes what things look like—from the familiar colors we live with all the time to contrasting grays that we only see in photographs—it makes us think about what we're looking at photographically.

Respect for historic accuracy and choice of black and white film both are important to defining Salt's documentary photography. But perhaps the most important definition involves time. Most photojournalism today is observational, a quick study with a camera simply because it cannot afford to be more. Good documentary photography takes a lot of time in the field.

And good documentary photography at Salt takes *many* times in the field. This repetition of going back again and again over a period of eight to thirteen weeks works many wonders. First, it's most helpful in establishing a rapport with the subject. Building on a more knowing intimate relationship with the subject visually and editorially, the photographer moves past the observational to the participatory. At Salt, photography is something of a contact sport.

Second, it allows for photographic study. Things look different in photographs than they do out in the field, and as Salt photographers begin to understand that visually through the editorial process, they are able to reconcile their shooting to the content when they go back into the field.

Also, we attune our photography to the complete anatomy of the subject documented— that is photographers explicitly search out visual evidence of the time, place, characters,

activities, and moods of the documented. This practice attempts a more scientific or objectified viewpoint. It anchors the photographer's picture-making impulses to the specifics of the subject. As a result, form is most often a consequence and not a cause in the documentary process. But that's not quite the whole story. Salt's photography is not free of the same traditional tensions mentioned earlier.

The structural needs of Salt are not singular. If the archive and its service to historical content and posterity demand that we photograph without penance to the graphic significance of our pictures, the commercial or editorial demands of *Salt* magazine certainly require graphic literacy. Significant content demands significant treatment. After preliminary research and photography that establish content veracity comes the editorial push to engage our readership today, not just the historians tomorrow.

The creative tension is to get photographers to empower the content of their photo stories with interesting frames without overpowering them with artifice. In this case form has an important function. The consequence of this process is that content is served if the photograph is visually more understandable. Cogent visual organization facilitates insight and resonance. Strong compositional elements are like road signs—they can help us find our way into a photograph.

Bert Cass's photo of Dario Mayorquin (pp. 122–123) epitomizes this relationship. Cass was documenting the residents of the YMCA for a photo essay, focusing on their relationship to the Y and how that relationship might define their identities. This over-the-shoulder framing of Dario shaving in the washroom almost begs the question of what Dario sees in the mirror. This is especially so with another person reflected in the right part of the photograph looking intensely in the direction of Dario. The photo is more about looking and reflecting than shaving in the Y. Bert's composition of this is bold. The striking diagonal of the mirror's edge slices the top half of the photo from the bottom half just as it ties together the left side of the frame with the right side. It's a kind of double entendre. This diagonal visually supports the imagined line of eye contact between

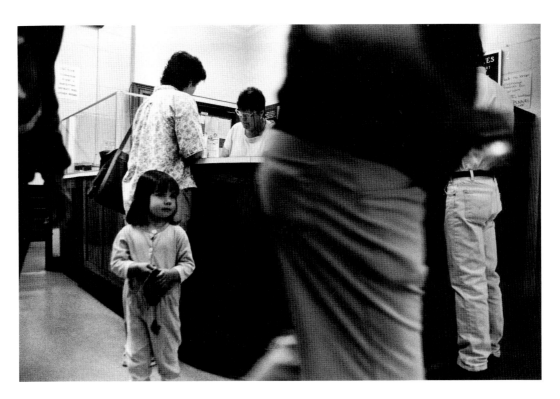

Fig. 1

the subjects on either side of the frame just as it separates the real Dario from the reflected one. The visual construct in this case *is* content. It too is about looking and reflecting. And the fact that this kind of composition was found and not arranged adds to its authenticity.

However, as suggested earlier, there are certain times that editorial needs demand that content fit our form. Bert shot over 1,500 frames of the people using the Y—from the residents, for whom their Y room is one step away from homelessness, to the doctors and professionals who take a break for a game of squash. Yet he still didn't have an individual photo that showed any real diversity. Rarely were the residents anywhere near the squash group or the basketball crowd near the water aerobics class. But in fact, all of these people and more lived or played or worked out under this one roof, and the archive had 1,500 photo frames to prove it.

Salt magazine, on the other hand, needed only one single frame for its story lead. The front desk of the Y was finally staked out at all hours for that one moment when enough types of people might be present to be squeezed into one photographic frame. The picture (Figure 1) here has at least part of six people of different ages, gender, body, and background types to suggest the Y as a stewpot kind of place. This photo was made in the thirteenth week of Bert's involvement with the Portland Y.

What is attempted by the students at Salt is that with enough time—and repeated times in the field with enough edits in between—intelligent frames can be found often enough within the history being photographed to engage both the eye and mind. Yet sometimes, like this time, form imposes its own dictates on the documentary functions at Salt.

If the documentary tradition is the heart of our photography, and the institutional needs of the archive and magazine act as our brains, the soul of Salt photography is Maine. Maine is a unique place. It seems to breed and attract unique people. To most, it is an end-of-the-line kind of place, somewhere you have to go to because it's not on the way to anywhere else.

As such, Maine stands apart. It succumbs to change in fits and starts only as it has to. Outside influences are farther away from Maine than in most places. If there is anything that seems closer to Maine than other places, it's the old ways. They seem to hang on longer here. Maybe because Maine is bigger geographically than all the rest of New England put together, there seems to be a greater ability to absorb change more gradually.

You can see this in our photographs. While the industrial age textile mills of Lewiston still weave fine cotton bedspreads on their jacquard looms, they've had to find new contracts for Southwest designer "throws" to stay in business (pp. 66–69). Age-old fishing families now sell their catch at a new computer-age fish market in Portland (pp. 18–19). Many of Aroostook's potato fields no longer grow potatoes. Broccoli is the new crop of "The County." While those converted potato fields are still growing things, they are harvested by new types of workers in Aroostook, migrant workers from the Philippines, Texas, and Mexico (pp. 56–57).

Maine is as much a state of mind as a place, and that impacts on how we photograph. As a documentarian in Maine, one tends to be more respectful of the individual in the traditional way than one might be in a rush-hour subway under the East River in New York City. As such, our photographs are probably more personal and direct and less confrontational and aggressive than photos from some other parts of the country. Even when our photographs relate to some of the difficult issues of the period—racism, sexism, or AIDS, for example—the photos speak more of people than politics. Jeffery Jordan's portraits of HIV-positive people are more evocative of individualities than of disease and death (p. 126).

The contrasts and complexities that make up the nature of the state of Maine abound in the pictures in this book. They enrich the ironies and multiple meanings of the photographs. Whether Salt photographs are rich in history or visual flare or, hopefully, a bit of both, they are full of Maine. It's what they're made of.

NOTES

Figure 1 is reproduced courtesy of Salt Documentary Archive.

1. William A. Frassanito, *Gettysburg: A Journey in Time* (New York: Macmillan, 1976).

2. Fred Richin, "In Our Own Image," *Aperture*, 1990, pp. 44–63.

3. *National Geographic*, February 1982.

UNIVERSITY PRESS OF NEW ENGLAND
publishes books under its own imprint and is the publisher for Brandeis University Press,
Brown University Press, Dartmouth College, Middlebury College Press, University of New
Hampshire, University Press of Rhode Island, Tufts University, University of Vermont, Wesleyan
University Press, and Salzburg Seminar.

Library of Congress Cataloging-in-Publication Data

Maine, a peopled landscape : Salt documentary photography, 1978 to 1995 /
 edited and with an introduction by Hugh T. French ; essays by C.
 Steward Doty, James C. Curtis, and R. Todd Hoffman.
 p. cm.
 Contains photography most of which previously appeared in the
periodical, Salt, published by the Salt Center.
 ISBN 0–87451–716–8 (cl). —ISBN 0–87451–717–6 (pa)
 1. Documentary photography—Maine—Exhibitions. 2. Salt Center
for Documentary Field Studies (Portland, Me.)—Photograph
collections—Exhibitions. 3. Maine—Pictorial works—Exhibitions.
I. French, Hugh T.
TR820.5.M35 1995
779'.99741043—dc20 95–5471
 ∞